D1270244

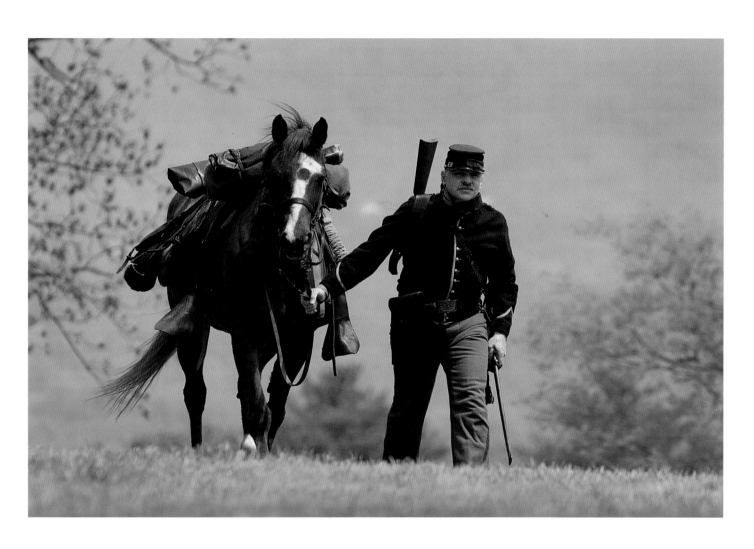

A volunteer reenactor portrays a Union cavalryman on Bolivar Heights.

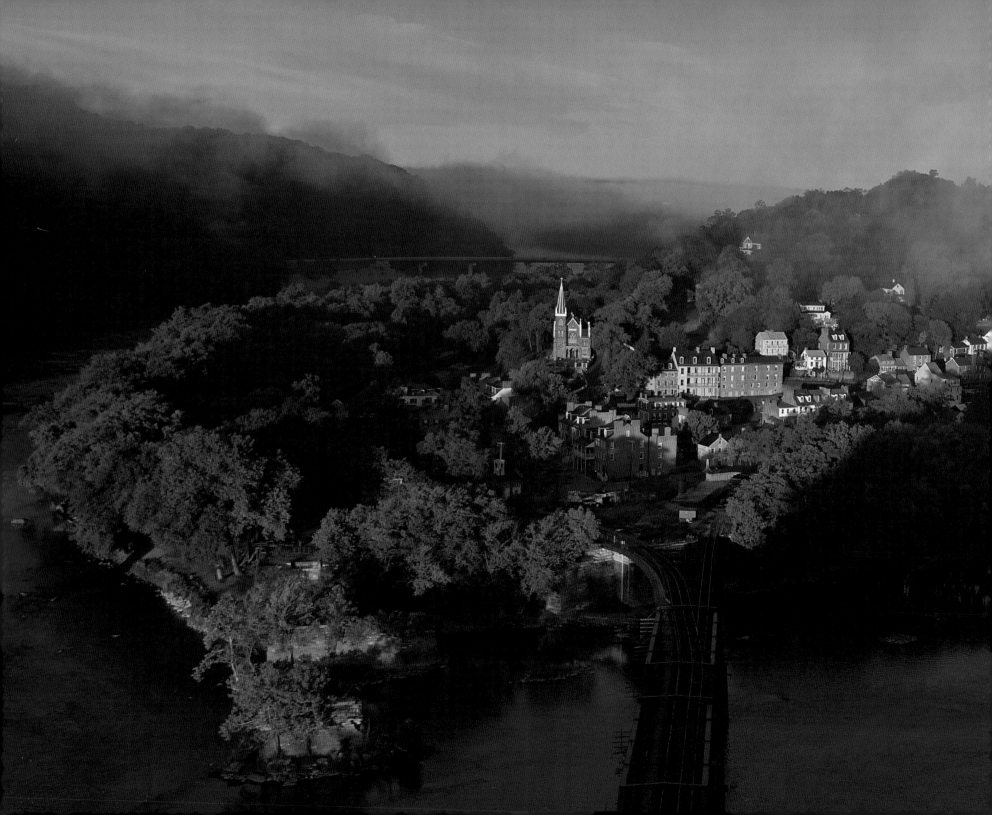

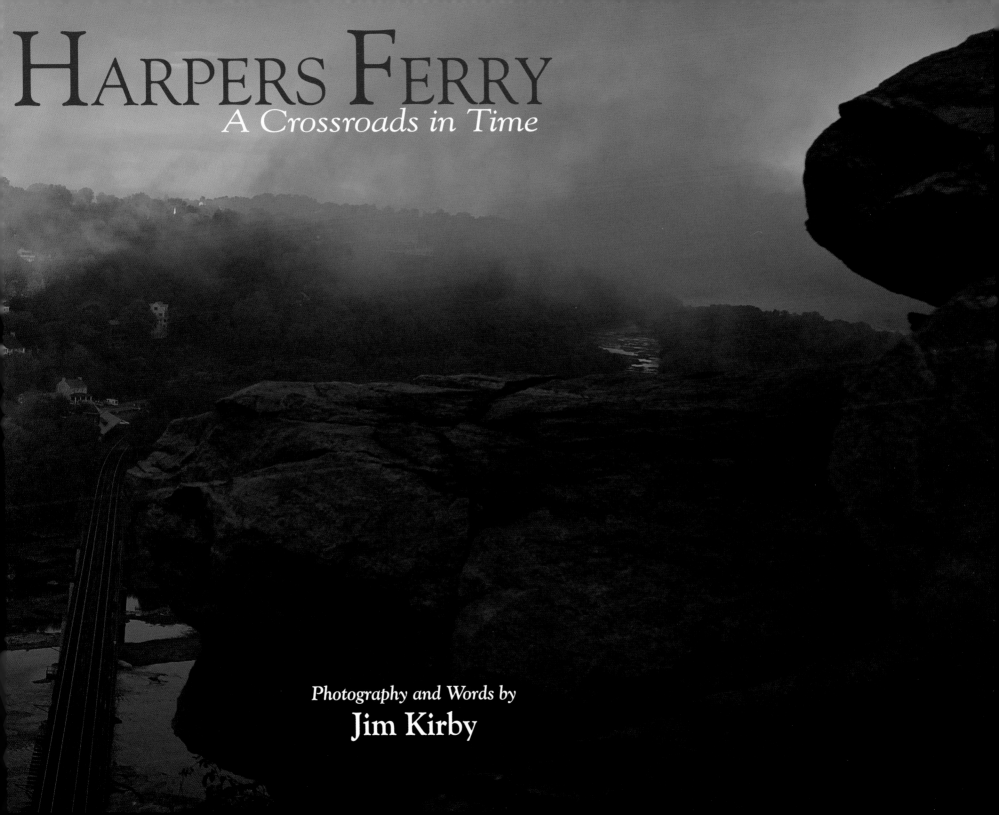

HARPERS FERRY
A Crossroads in Time

Photography and Words by
Jim Kirby

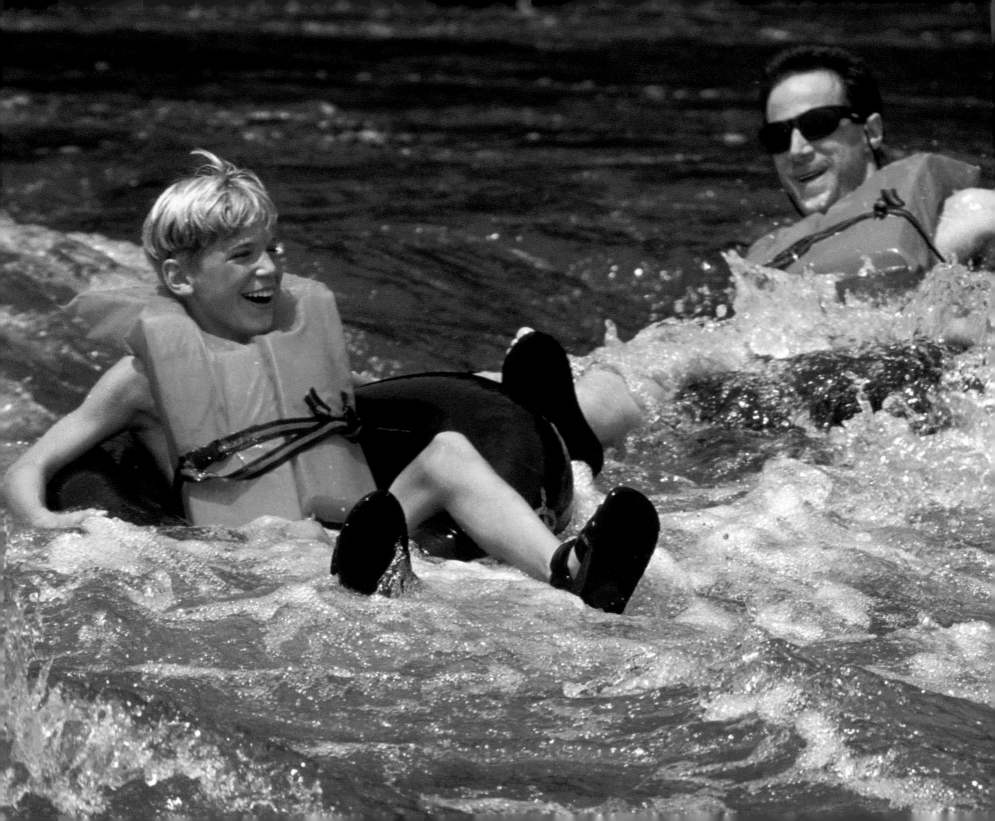

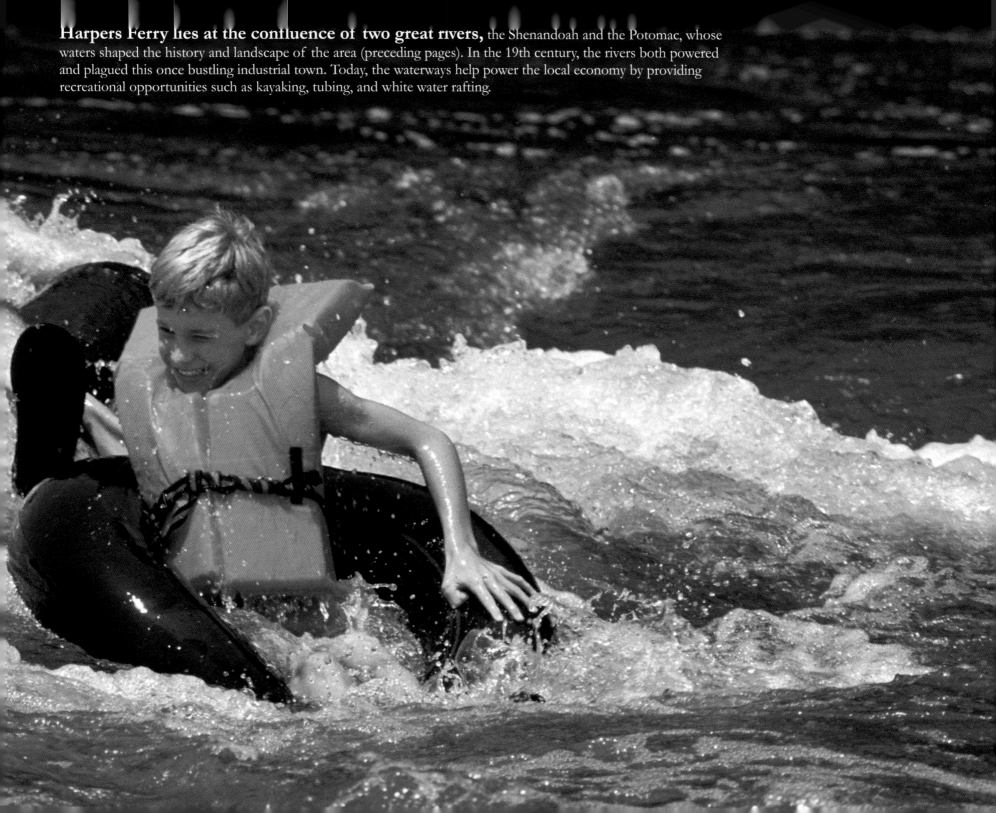

Harpers Ferry lies at the confluence of two great rivers, the Shenandoah and the Potomac, whose waters shaped the history and landscape of the area (preceding pages). In the 19th century, the rivers both powered and plagued this once bustling industrial town. Today, the waterways help power the local economy by providing recreational opportunities such as kayaking, tubing, and white water rafting.

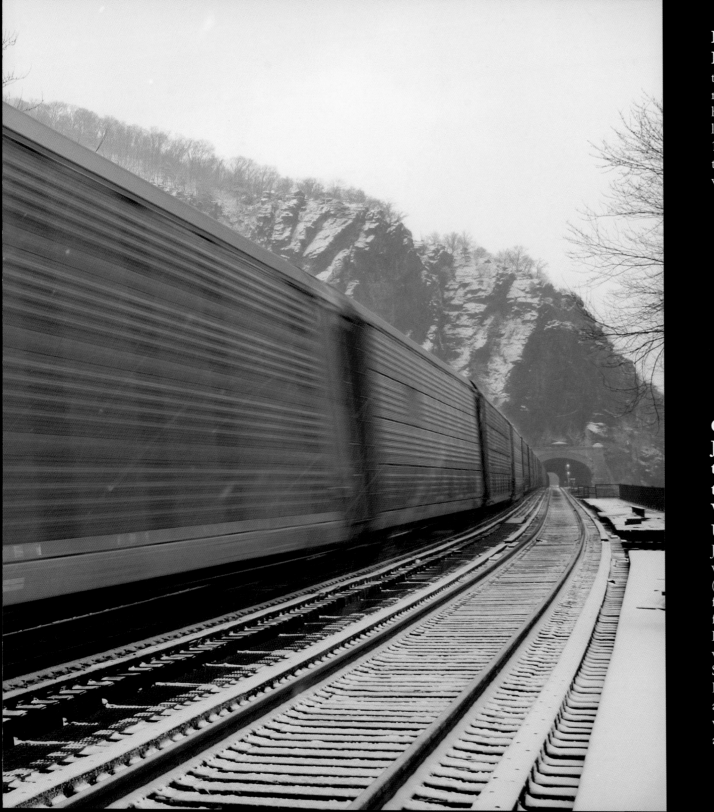

Freight trains no longer stop in Harpers Ferry, but they still rumble through on a regular basis, a powerful reminder of the town's transportation heritage. The town's industrial boom was linked to the arrival of the first trains in the 1830's. More than any other form of transportation, the railroads opened the west to economic expansion.

Confederate Colonel Thomas J. Jackson arrived at Harpers Ferry to assume his first command of the Civil War just ten days after Virginia seceded from the Union. Encamped on Bolivar Heights, Jackson drilled thousands of Virginia volunteers and exercised the great guns (overleaf). A devout Presbyterian, Jackson is fabled to have brought with him from VMI four old cannon nicknamed Matthew, Mark, Luke, and John. Six weeks later, Jackson withdrew his newly formed brigade into the Shenandoah Valley. He would return to the Ferry the following year a Major General and with the moniker "Stonewall." Jackson would lead his men in what became known as the Battle of Harpers Ferry.

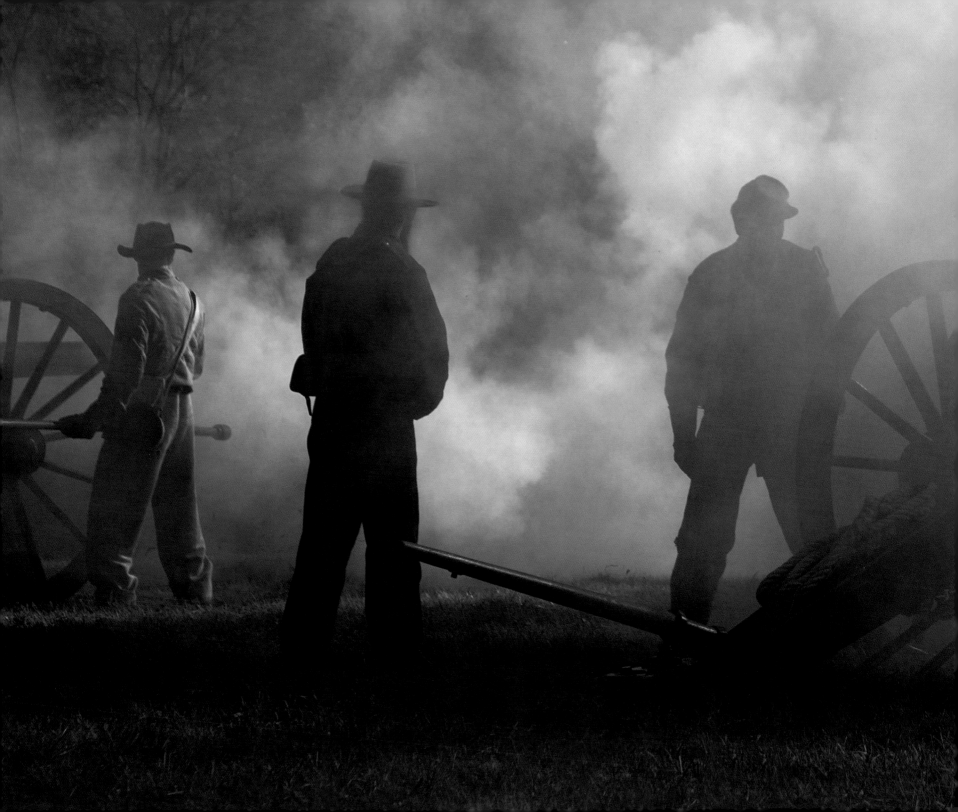

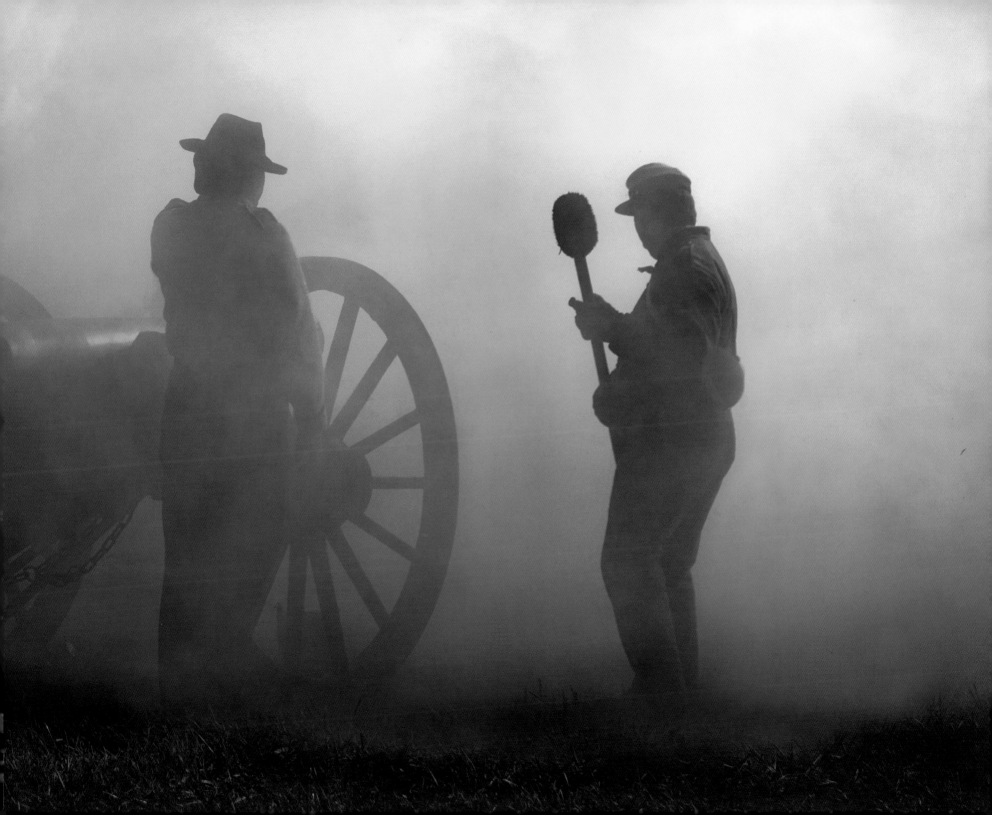

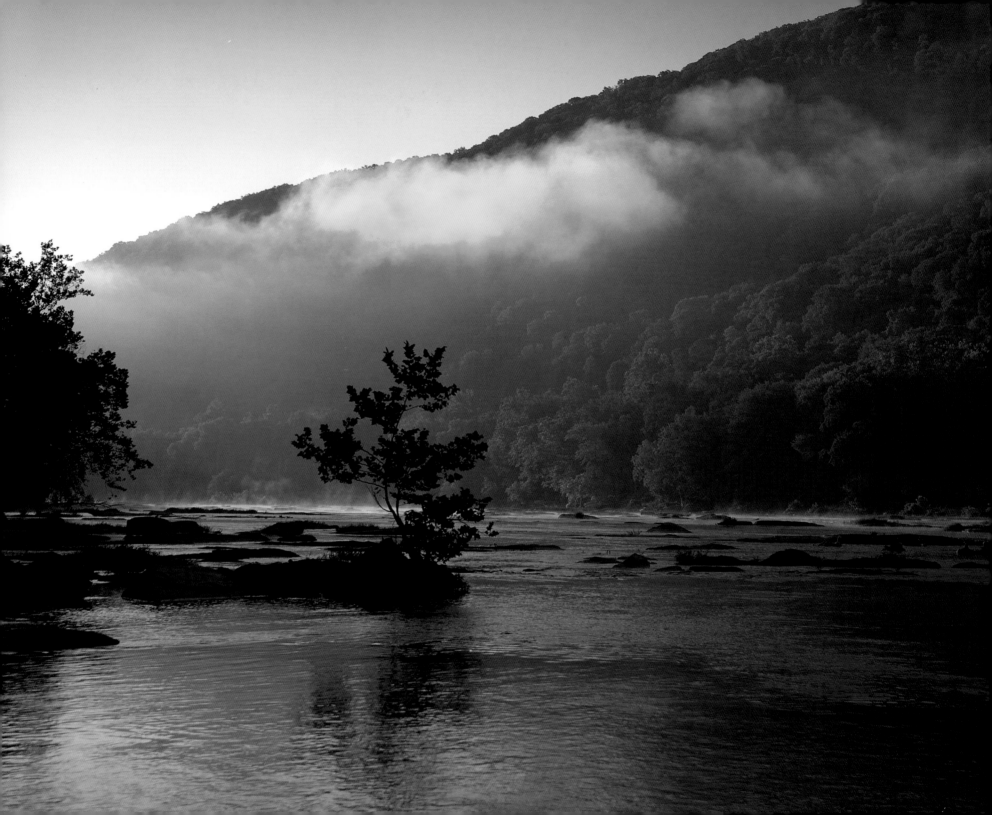

"...a most abominable little village" is how one British traveler described Harpers Ferry in the 19th century. Although the Federal Armory brought industry to this hamlet, the factory made it a dirty, smelly, and noisy place to live and work. The mountains surrounding the Ferry were striped of their hardwoods to provide charcoal for industry and fuel for stoves. In its industrial heyday, the area was a far cry from the pristine landscape Thomas Jefferson visited in the 1700's. Today, nature is reclaiming the ruins of the 19th century. Wetlands fill abandon waterways. The air is cleaner and the mountains are covered again in deciduous forest (left). The economic success that Harpers Ferry enjoyed in the 1800's came to an abrupt end at the start of the Civil War. The Federal Armory and Arsenal was set aflame by retreating Union troops, destroying 15,00 weapons. The fires were put out by townsmen in a vain effort to save their livelihood. Two months later, after shipping arms-making equipment south, the Confederates burned what remained. The only Armory building to survive was the fire engine house, which was fast becoming known as John Brown's fort (above). It was here in October of 1859 that the famed abolitionist made his last stand before being captured by U.S. Marines. Fearing the eloquence of his celebrated prisoner, Virginia's Governor Henry Wise quickly tried and hanged Brown for treason, but not before this martyr had polarized the country on the question of slavery. Just after the raid, the Richmond Enquirer wrote that Brown's deeds "advanced the cause of Disunion more than any other event that happened since the formation of the Government...it has revived with tenfold strength the desires of a Southern Confederacy."

HARPERS FERRY
A Crossroads in Time

Photographs and Words
Jim Kirby
www.jimkirbyphoto.com

MOUNTAIN TRAIL
PRESS

1818 Presswood Road • Johnson City, TN 37604
www.mountaintrailpress.com
Celebrating America's Most Scenic Places

Book Design and Layout: Jim Kirby & Jerry Greer
Editor: Abbey Jones & Ian Plant
Entire Contents Copyright © Mountain Trail Press
Photographs and text © Jim Kirby
Published by Mountain Trail Press
ISBN: 978-09799171-7-2
Library of Congress Control Number: 2009900508
Printed in China, Winter 2009.

Contents

Introduction 15

A Village in Time 18

Two Great Rivers 40

The War Years 56

On The Move 74

John Brown's Legacy 94

A Natural History 102

St. Peter's Catholic Church on a foggy morning

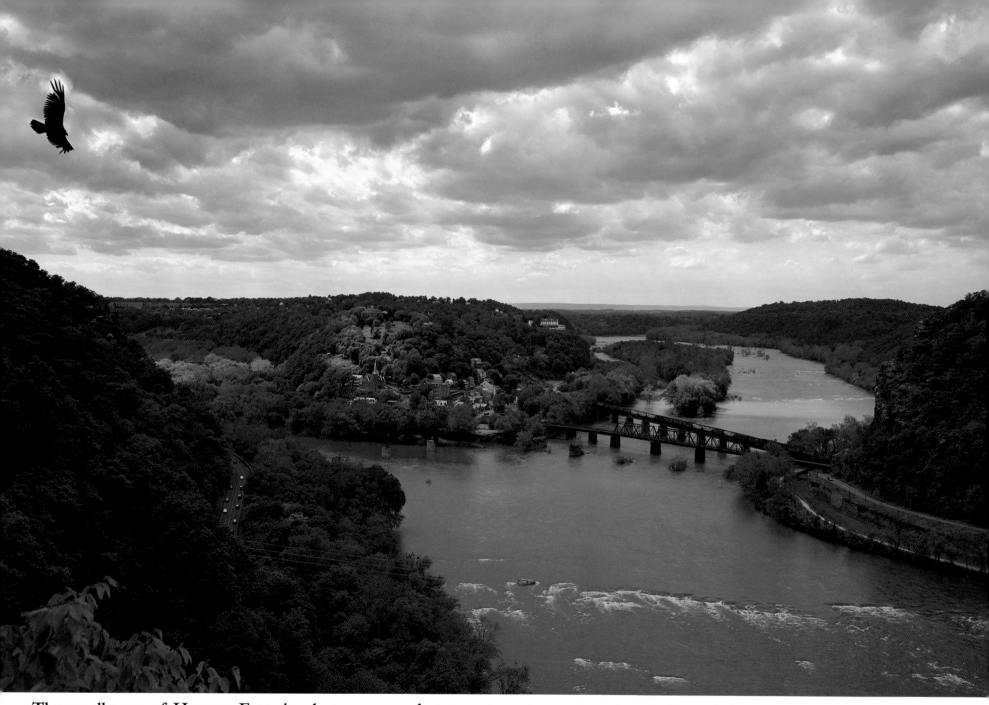

The small town of Harpers Ferry is a busy crossroads. It lies at the confluence of two rivers, the Shenandoah and the Potomac. Three states converge here, Virginia, Maryland, and West Virginia. Two active railroad lines run through Harpers Ferry. In Maryland, the Chesapeake and Ohio Canal runs along the riverbank of the Potomac, its towpath a popular hiking and biking trail. And the Appalachian Trail descends from the Blue Ridge Mountains and crosses through the historic town. This perspective is from Loudoun Heights, a rocky bluff in Virginia. Heavily traveled U.S. Route 340 passes through the south side of the famed water gap.

Introduction

What draws most visitors to Harpers Ferry, West Virginia is the history. In October of 1859, the radical abolitionist John Brown of Bloody Kansas infamy stepped from the shadows of his Maryland hideaway and led a doomed raid on this small industrial town. His intention was to seize arms at the Federal Arsenal and lead an insurrection of slaves. After fighting with townsmen and local militia, Brown and his remaining men were soon captured by U.S. Marines. Led by Army Colonel Robert E. Lee, the Marines had been rushed to the scene by rail from Washington. Brown's foolhardy scheme was over, but his audacious act, and the storied trial and hanging that followed, forced the nation's hand. The divisive issue of slavery had to be confronted. All of the other sectional issues dividing the country at the time might have been settled by compromise, but not slavery, that "peculiar institution" of the south. Within sixteen months, the country was at war. The long and bloody conflict ultimately sealed the fate of this 19th century industrial town.

A fascinating history to be sure. But in all honesty, what first attracted me to this river town are all the wonderful views from the surrounding ridges. Across the Shenandoah River from the lower town, Loudoun Heights has several craggy overlooks accessible from the Appalachian Trail, which passes through Harpers Ferry National Park. High above the town to the west is Bolivar Heights, where President Lincoln reviewed Union troops after the Battle of Antietam. Today, visitors to this grassy ridge are treated to a panoramic view, along with a history lesson on the siege of the town by Stonewall Jackson. Just above the lower town is the famed view at Jefferson Rock, a short walk up rough steps hand-carved in the Harpers shale. From this high ground over two centuries earlier, Thomas Jefferson (portrayed by Bill Barker, above) beheld a view "worth a voyage across the Atlantic." To think I travel but an hour by car to reach this scenic place. Jefferson wrote that the view is "one of the most stupendous scenes in Nature." Indeed it is.

But my favorite overlook by far is Maryland Heights. Across the Potomac from the lower town, this large outcropping of rock towers above the confluence of two great rivers. From here the view of Harpers Ferry and the rugged beauty of the surrounding landscape is unmatched. A hike to the top in early morning finds squadrons of honking geese flying up and down the rivers. Far below, fishermen wade the shallows of the Potomac, casting about for smallmouth. As the air warms, vultures begin sailing the invisible currents flowing along the ridges. Soon the first tourists of the day appear. With binoculars, it's fun watching all the comings and goings of this hillside river town.

Some visitors arrive by train. Amtrak and MARC make daily stops at Harpers Ferry. The railroad is a loud and clear reminder of the town's role in opening up the west. The B&O Railroad's arrival in 1834 ensured the economic boom that was in progress. Already in place, the United States Armory and Arsenal continued to expand until the Civil War. Powered by the Potomac, the armory was spread over 125 acres with over two dozen buildings, only one of which survived the town's tragic history. The one small structure that remains served as the Armory's fire engine house. Today it is known as John Brown's fort.

One could easily spend a day poking around the exhibits and media presentations housed within a score of restored buildings. The National Park Service does a good job interpreting the town's history. But in my experience, the special living history programs that take place on many weekends are what best relate the life and times of this 19th century town. With the help of volunteer reenactors, the events bring the past to life. The Civil War years are the focus. Harpers Ferry was strategically important to both armies, the town changing hands eight times.

The U.S. Armory wasn't the only show in town. Private industry thrived as well. The Winchester & Potomac Railroad arrived in 1836,

bringing with it raw materials for the water-powered mills on nearby Virginius Island on the Shenandoah. Exploring the sparse ruins of this riverside ghost town demands a good pair of walking shoes and a vivid imagination. Not much is left of the once bustling town. Most of the mills lie in ruin, casualties of the periodic floods that plagued the island. The basement of the old cotton factory remains. And nearby, stone-lined arches have survived. These head gates once channeled water into the Inner Basin until needed by the mills. Otherwise, all that remains are the foundations of a few old mills. I'm grateful for the many interpretive signs that help flesh out the bygone town. And the breezy walk along the river is a delight.

In the 1850's Harpers Ferry was in its heyday. Residents numbered over two thousand. The Armory employed more than 400 workers and by 1861 had cranked out 600,000 muskets, rifles, and pistols. Then war broke out. The day after Virginia seceded from the Union, confederate militia advanced on Harpers Ferry. A small garrison of Federals, unable to defend the Armory and Arsenal, set them aflame. From that point on, the war took charge of the town. Many residents fled. Those who stayed experienced four years of hell as they witnessed the devastation of their homes, their lives, and their beloved town.

Harpers Ferry changed hands often during the war. The town fell under the authority of 28 different commanders. For the most part, Union troops occupied the town. But Confederate forces invaded and even occupied the Ferry at times, though generally not for long. If no army were about, the town was often harassed by southern partisans operating out of the Shenandoah Valley. Harpers Ferry was involved in two Valley Campaigns, Stonewall Jackson's in 1862 and Philip Sheridan's in 1864. The town also played a role the Confederate invasion of the north in 1862. On the eve of the great battle at Antietam, Lee sent Jackson to capture the Ferry. This famous siege became known as the Battle of Harpers Ferry. Over 12,000 Federals surrendered.

In the end, the war was a staggering blow from which this small industrial town never fully recovered. The knockout punch came in the form of a ravaging flood in 1870. But thanks to the Park Service, 19th century life in Harpers Ferry is alive and well—at least on weekends, when volunteers and tourists come together to experience another time.

If one chapter of the town's history closed with the end of the war, another one opened. Soon after the fighting was over, Freewill Baptist missionaries took possession of several vacant armory buildings up on Camp Hill, where they founded Storer College, one of the nation's first black institutes of higher learning. Initially established to educate former slaves, Storer grew from a one-room school into a full-fledged teachers' college. Primarily a black school, the college was open to students of all races and both genders. A year after the 1954 Desegregation Act became law, Storer College closed its doors.

Some visitors to Harpers Ferry skip the history lesson altogether and take to the two rivers that converge here. Whether it's paddling a raft, fishing from a canoe, or floating in a tube, there is something for everyone. Local outfitters offer a variety of trips, from beginner tubing to advanced kayaking. Another favorite pastime with visitors is hiking the many trails in the park. On Maryland Heights, trails lead hikers to the remnants of Civil War fortifications and to overlooks that offer wonderful views of rivers and range. Most hikers are out for an afternoon jaunt. But come spring, a different breed is often seen backpacking through town: the Appalachian Trail through-hiker. The headquarters for the AT Conservancy is located in the upper town.

A trip to Harpers Ferry would not be complete without an outing along the Chesapeake and Ohio Canal. From its eastern terminus in Washington, D.C., the C&O winds its way through the Maryland countryside for 185 miles, hugging the Potomac all the way to Cumberland. Today, the towpath is a popular hiking and biking trail. A walkway running along one of the railroad bridges allows easy access to the C&O from the lower town. Much of the path is shaded, so even in the summer, a walk along this beige ribbon is a pleasant diversion, with breezy views of the Potomac.

Late in the day, I scramble up a secluded path to Maryland Heights. Here I have a glorious view of the sun setting over the rivers and town. It's a clear evening, and as the sun sinks behind the mountains, the afterglow turns river and sky the same deep red, a fitting end to another day in this timeless place. In the half-light, I head back to my car and the voyage home.

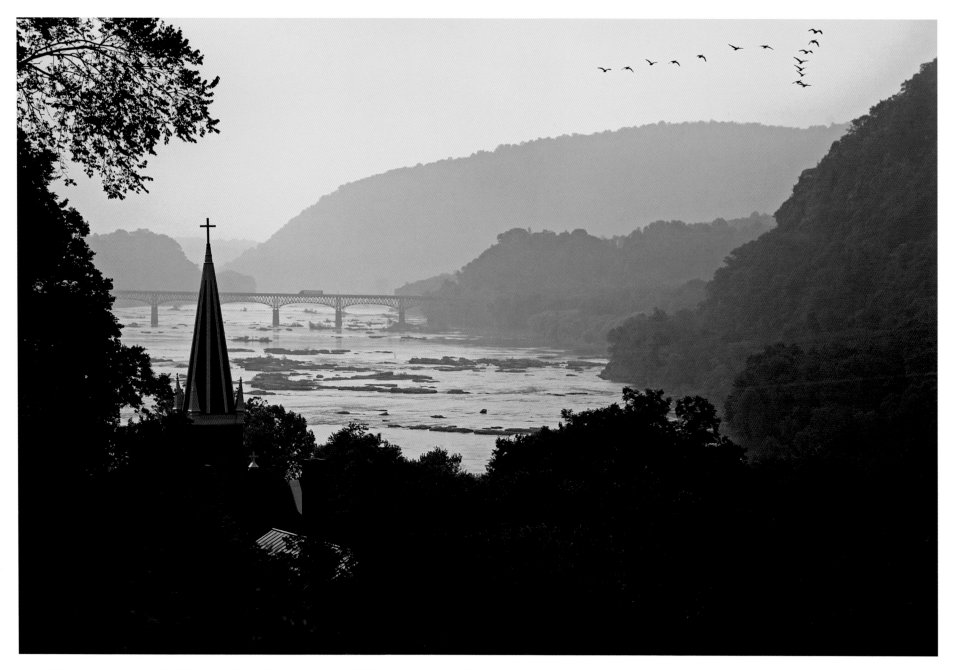

The view from Jefferson Rock is not so different today than it was in 1783, when Thomas Jefferson visited Harpers Ferry and praised the scene as "one of the most stupendous...in Nature". St. Peter's Catholic church is now visible, as is the Route 340 bridge in the distance. But otherwise, the rugged beauty of the gorge is much the same.

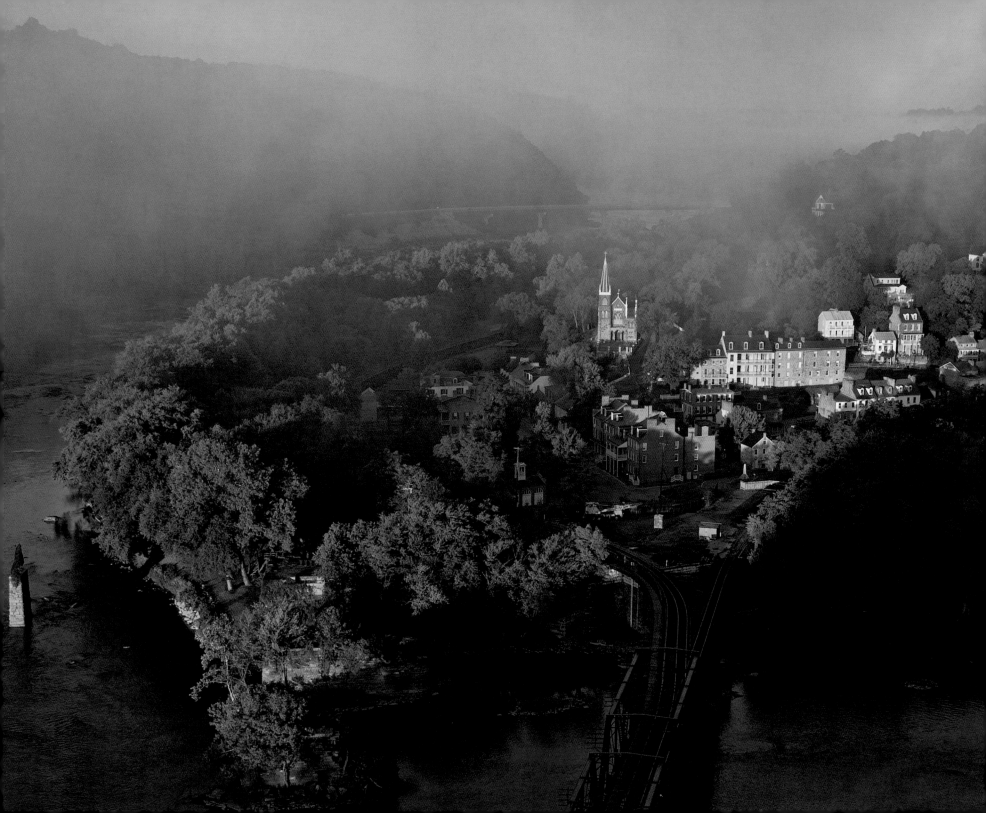

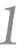

A Village in Time

An abiding sense of the past inhabits Harpers Ferry. The haunting presence of another time lingers here like an autumn mist slow to leave. A visitor to this place has a foot in both the past and the present, in both a 19th century industrial town caught up in the turmoil of a nation at war and a scenic national park that offers hiking, fishing, and river rafting. Surrounded by the Blue Ridge Mountains, Harpers Ferry lies at the confluence of two great rivers, the Shenandoah and the Potomac. Together these waters shaped both the landscape and the history of the area. The Federal Armory and the many water-powered mills that made this a bustling industrial town in the mid-1800s are mostly gone, replaced by the National Historic Park's interpretive museums and a variety of shops and restaurants. The railroads that helped drive the industrial boom of the 19th century are still active. But cars and trucks have taken the place of horses and wagons. Harpers Ferry remains a place many call home, but residents are no longer ordered about by a Provost Marshal, as often happened during the Civil War. To be sure, Harpers Ferry is not the same place it was a 150 years ago. Still, a large and lasting remnant of the 19th century town is here to explore. And the story that it tells is nothing less than the story of America.

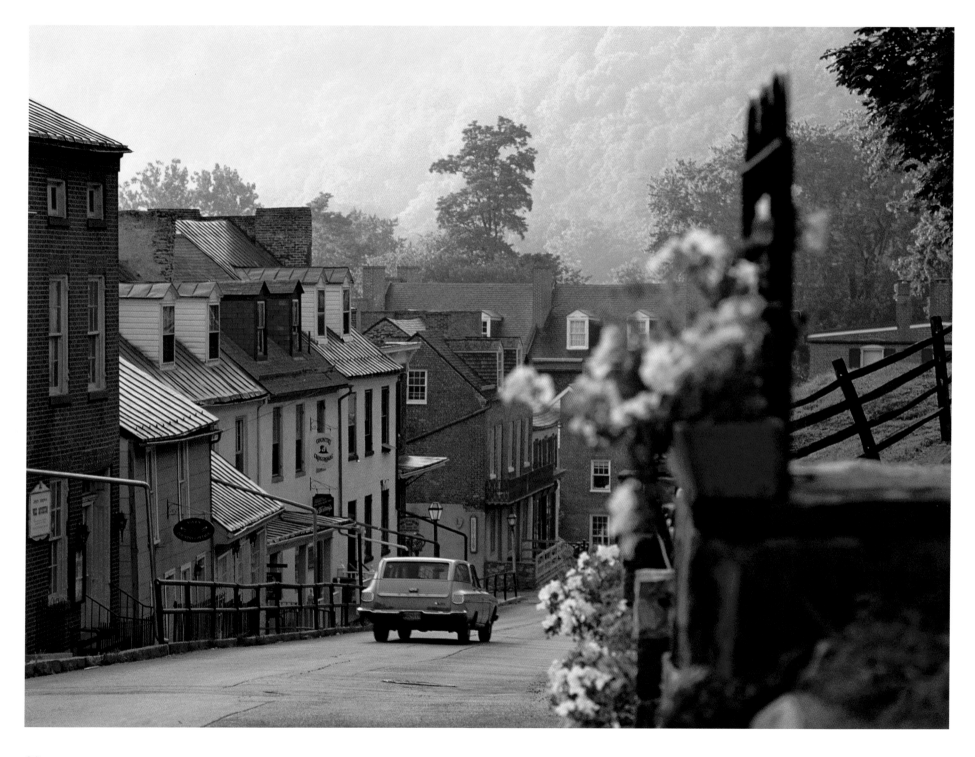

The historic town of Harpers Ferry opens a window on the past. Many of the buildings, including Frankel's clothing store (right), are clustered along Shenandoah Street. A short walk up the Stone Steps is the Harper House, which offers a unique view of the lower town (below). The oldest surviving building in the town, the Harper House displays the apartment of a 19th century armory worker. An old station wagon eases down a very steep High Street (opposite), which descends from the upper town of Harpers Ferry. Passing by a score of shops and restaurants, the car heads toward Shenandoah Street and the restored town in the National Historic Park.

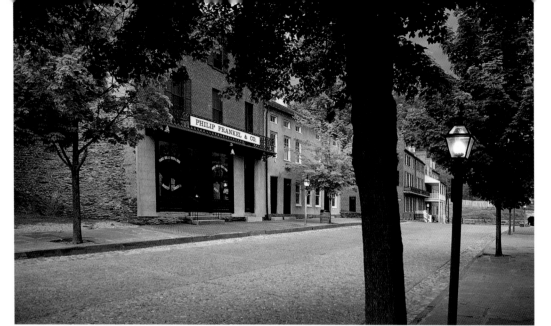

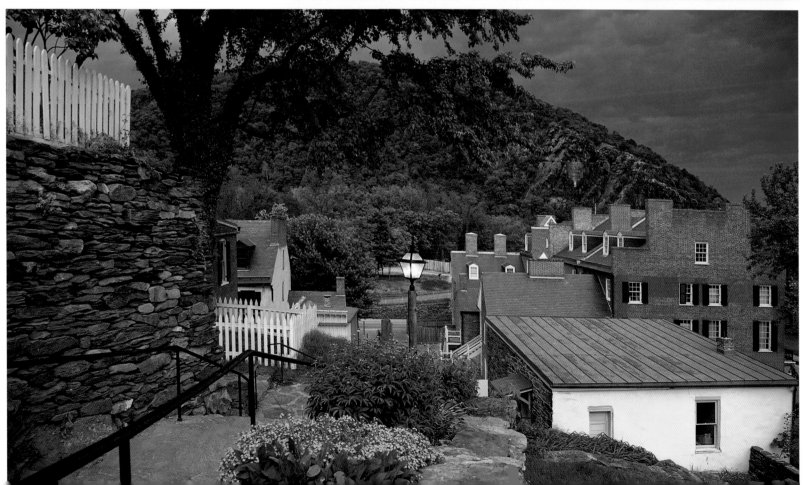

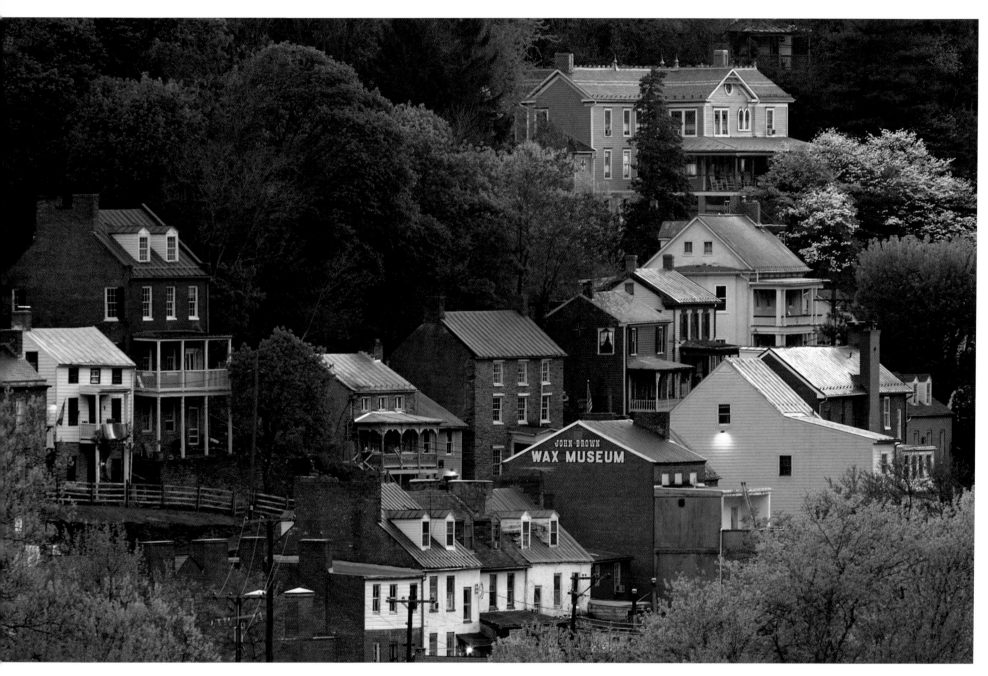

The hillside town is home to many residents and small businesses (above), mostly shops and restaurants that cater to the park visitors. St. Peter's Catholic Church (opposite), completed in 1833, was the third church built in Harpers Ferry and the only one not severely damaged or destroyed during the Civil War. At its height before the war, the town's population had reached over two thousand. Today, the residents of the Ferry number less than four hundred, most living in the upper town.

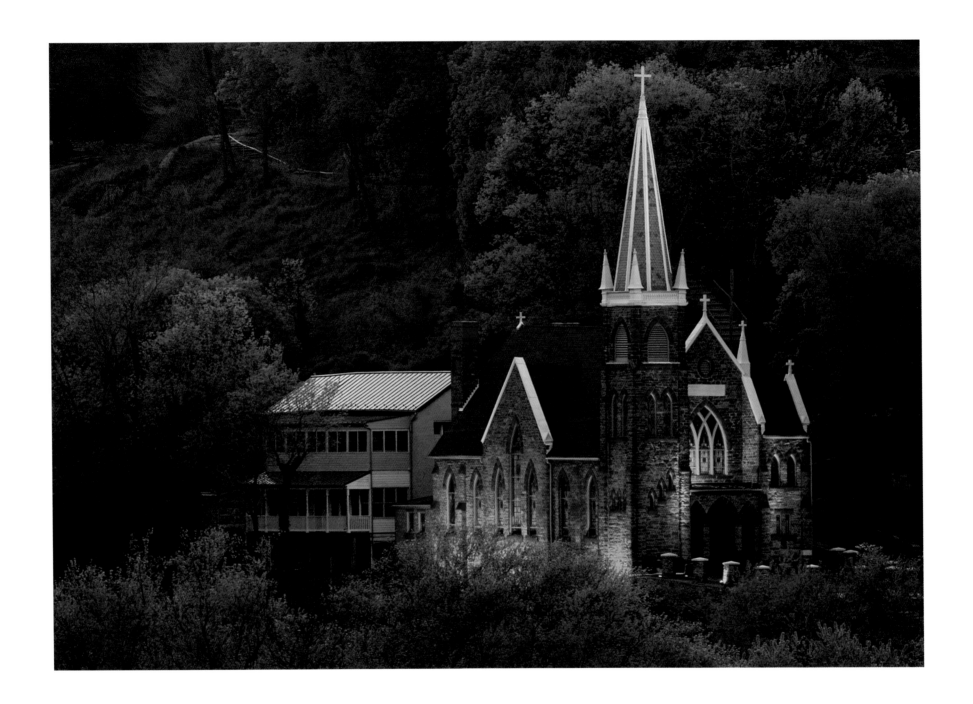

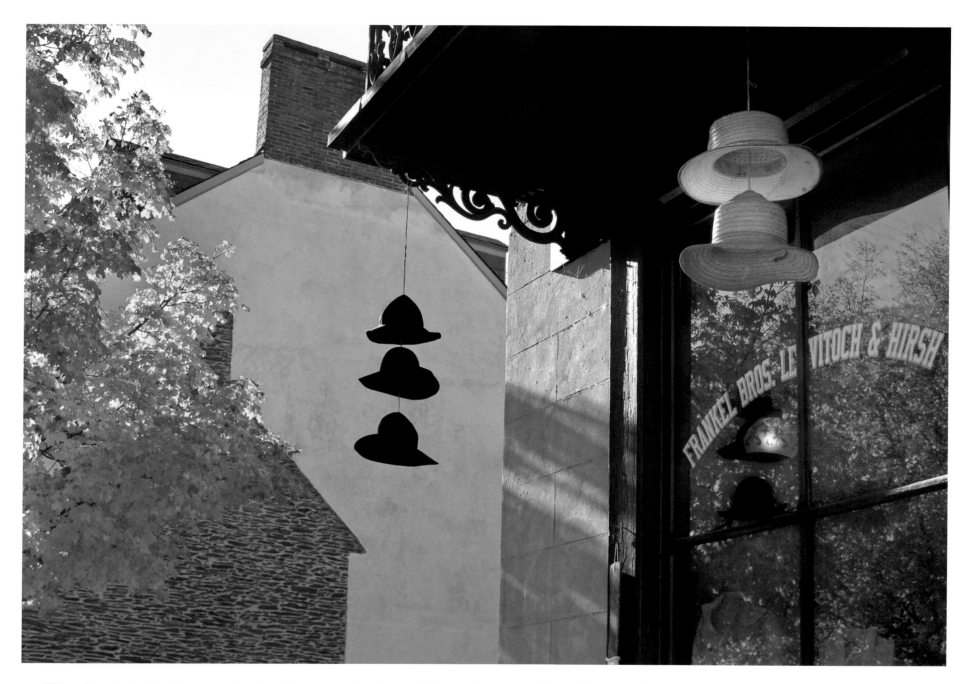

Whether it is the ironwork of a fence or the tinwork hanging outside a dry goods store (right), the attention to detail promises to both charm and edify park visitors. Nineteenth century style hats hang outside Frankel Brothers (above), a restored clothing shop on Shenandoah Street. Serving as the town's landmark, the tall steeple atop St. Peter's was added when the church underwent extensive renovations in 1896 (far right).

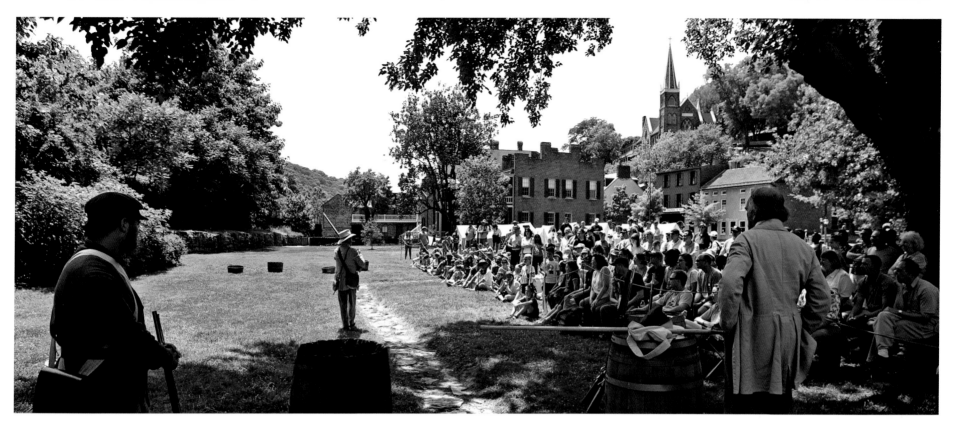

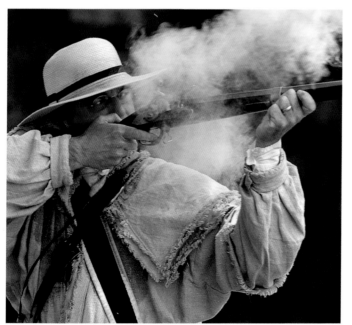

For the first sixty years of the 19th century, Harpers Ferry was a company town, the company being the United States Armory and Arsenal, which produced over 600,000 rifles, muskets and pistols. Firing demonstrations draw a big crowd to the lower town on many weekends throughout the year. Interpreters give a most interesting account of the innovations in the technology of arms production. Open year-round, an industry museum (opposite) features original machines used in the manufacture of weapons.

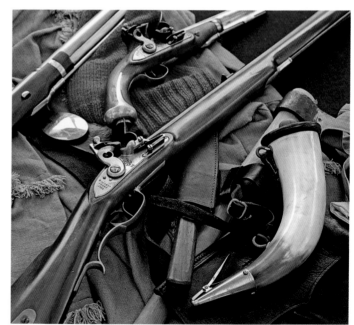

Hall's Rifle Works on Virginius Island was the site of the first successful use of interchangeable parts in manufacturing. During the 1820's and 30's, John Hall perfected machinery that enabled workers to manufacture breech loading rifles with interchangeable components. This was a major contribution to what became known as the American factory system. Hall's ingenuity inspired other inventors, such as Eli Whitney, to make pilgrimages to Harpers Ferry to see first hand "a plant of milling machinery by which the system and economy of the manufacture was materially altered," according to James Burton, master machinist at the armory.

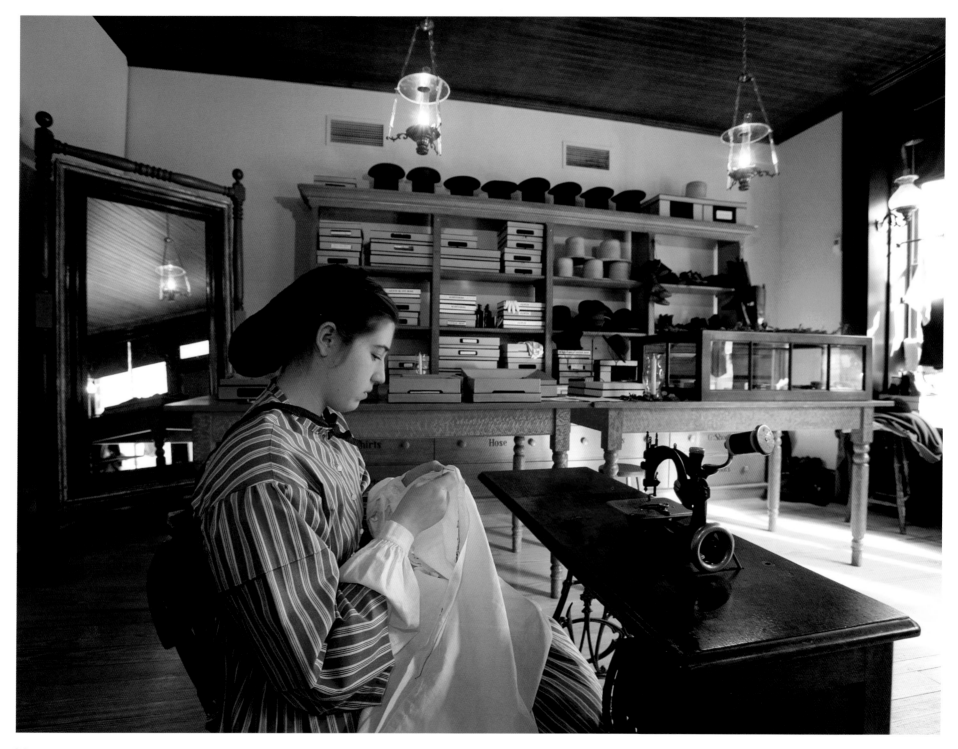

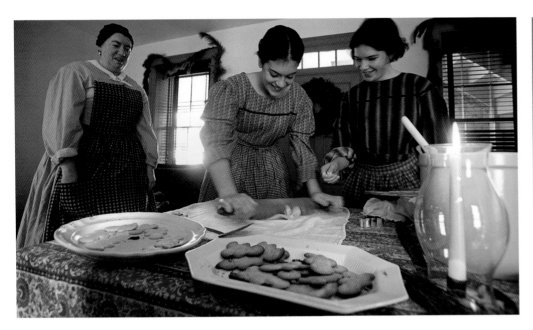

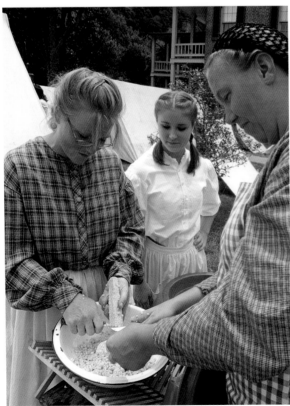

Interpreting the role of women in 19th century Harpers Ferry can be hard work. With the indispensable help of volunteers, the National Park Service sponsors living history programs that portray life in small town America and the big role women played. A seamstress works in Frankel's clothing store (opposite), which exhibits some of the mechanized advances in the 19th century clothing industry. But much of the work that women did–such as cooking, baking, sewing, spinning yarn, knitting and quilting–was by hand (this page and overleaf).

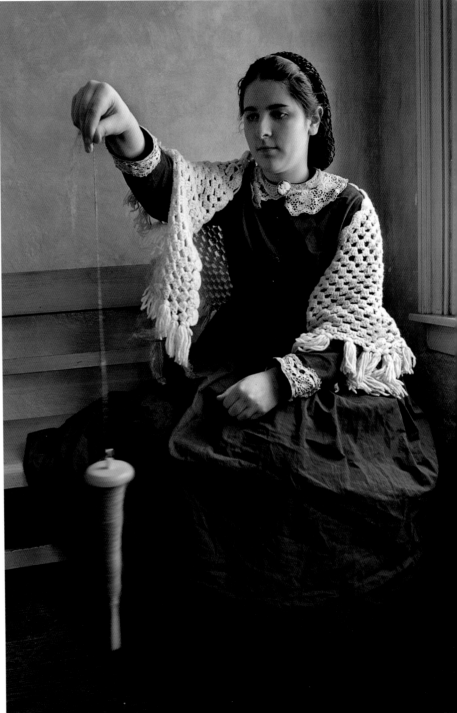

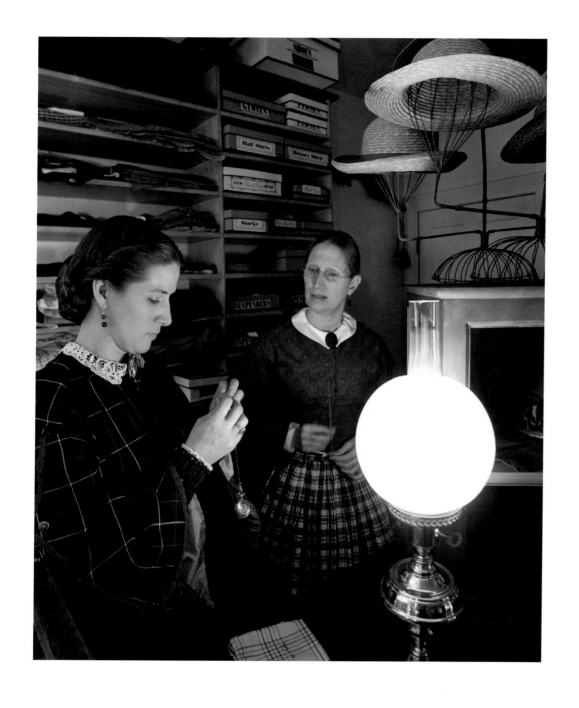

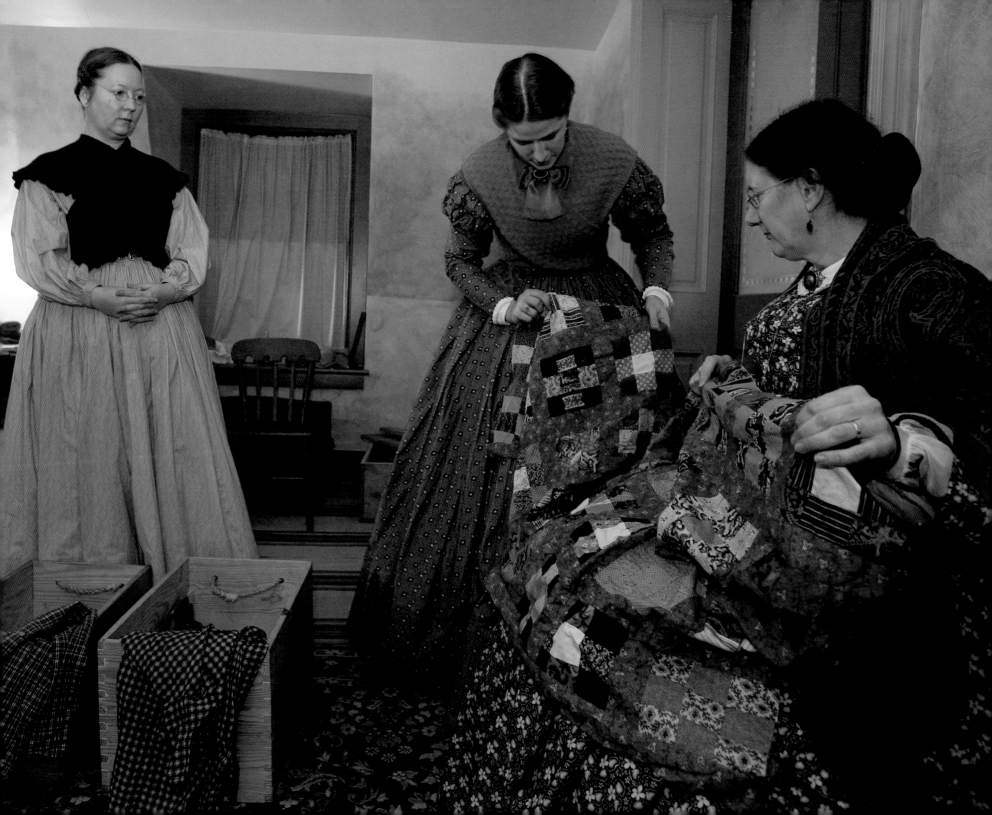

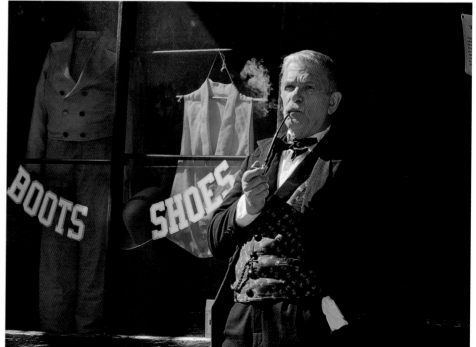

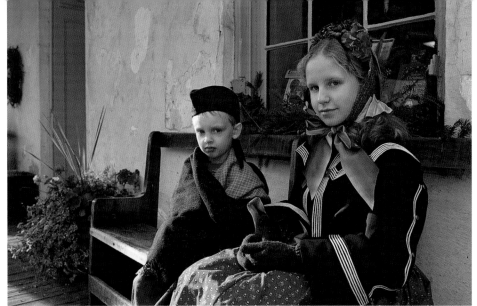

Portraying the people who lived in the 19th century town, volunteer reenactors, clad in period dress, bring to life the sights, sounds, and smells of the past. Each special living history event features a different theme, from "America's Picnic: Celebrating the Glorious 4th" to "Prospects of Peace: A Soldier's Prayer". The volunteers are from all walks of life and come from across the mid-Atlantic region. For many, it is a family affair. What they all have in common is a passion for history. They happily share their knowledge with visitors to this unique national park, which interprets the remarkable story of this early American town.

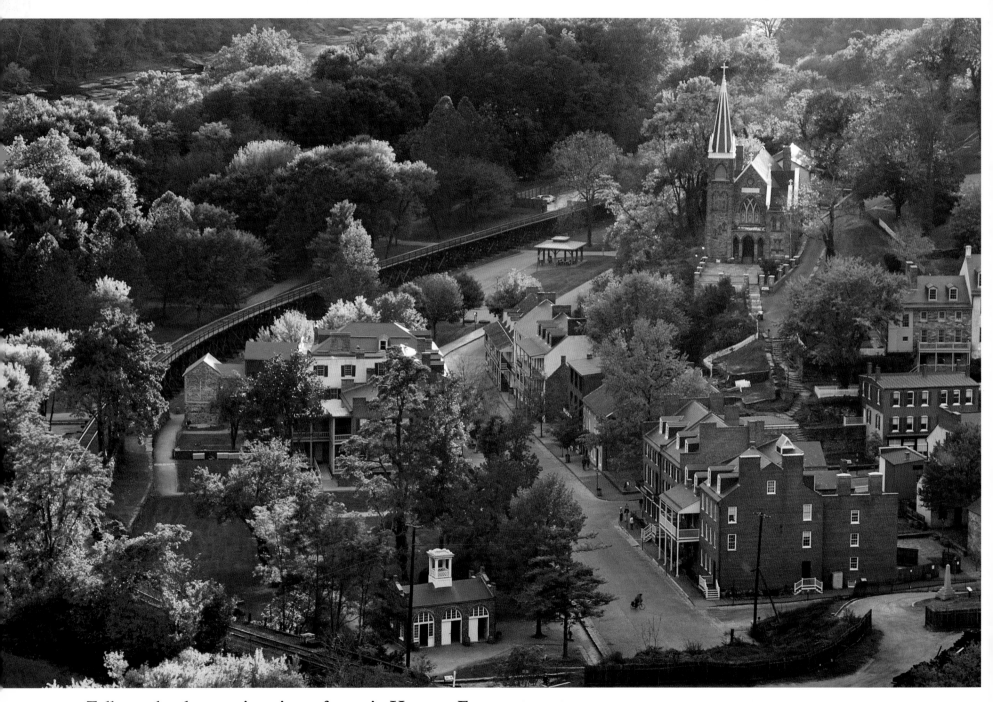

Fall may be the prettiest time of year in Harpers Ferry, and late afternoon is certainly a great time for taking in the scenery. From Maryland Heights, hikers have a wonderful view of the town with its many trees backlit by the sun (above). On a fall morning, as the town awakens, people begin to walk about the historic streets (opposite).

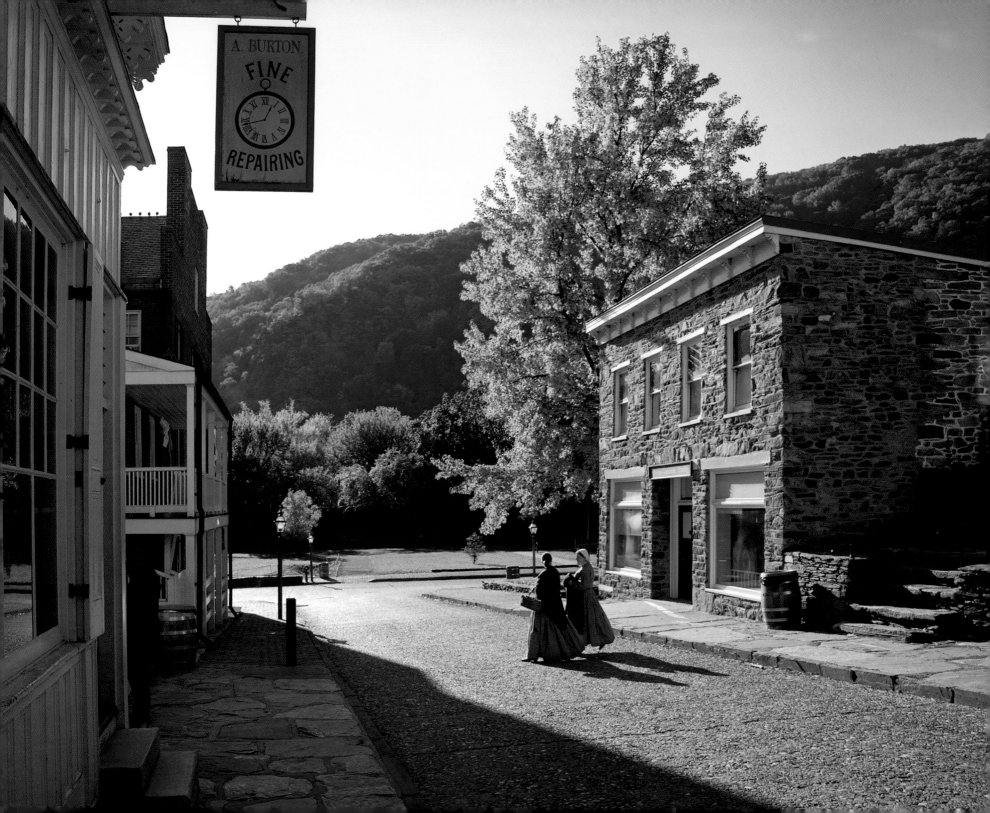

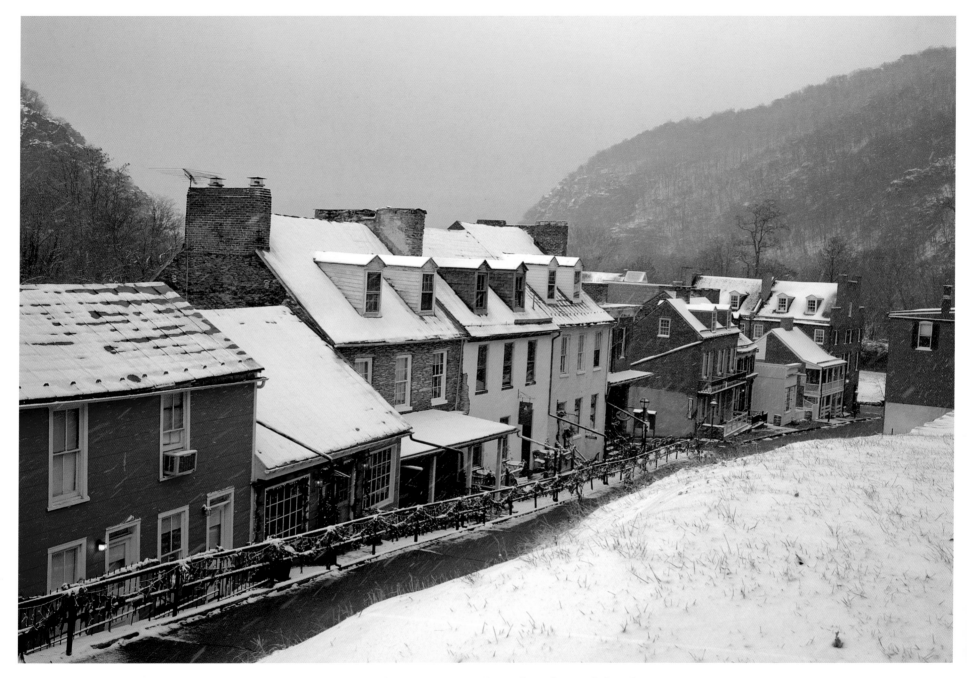

An early December storm coats the town and its greenery in a frosting of fresh snow (above). Near the Lockwood House on Camp Hill, a maple tree still clings to its leaves in the early snow (opposite). Originally built as the quarters for the Armory paymaster, the Lockwood House became the first home to Storer College shortly after the Civil War. During the war, General Sheridan, among others, used it as his headquarters.

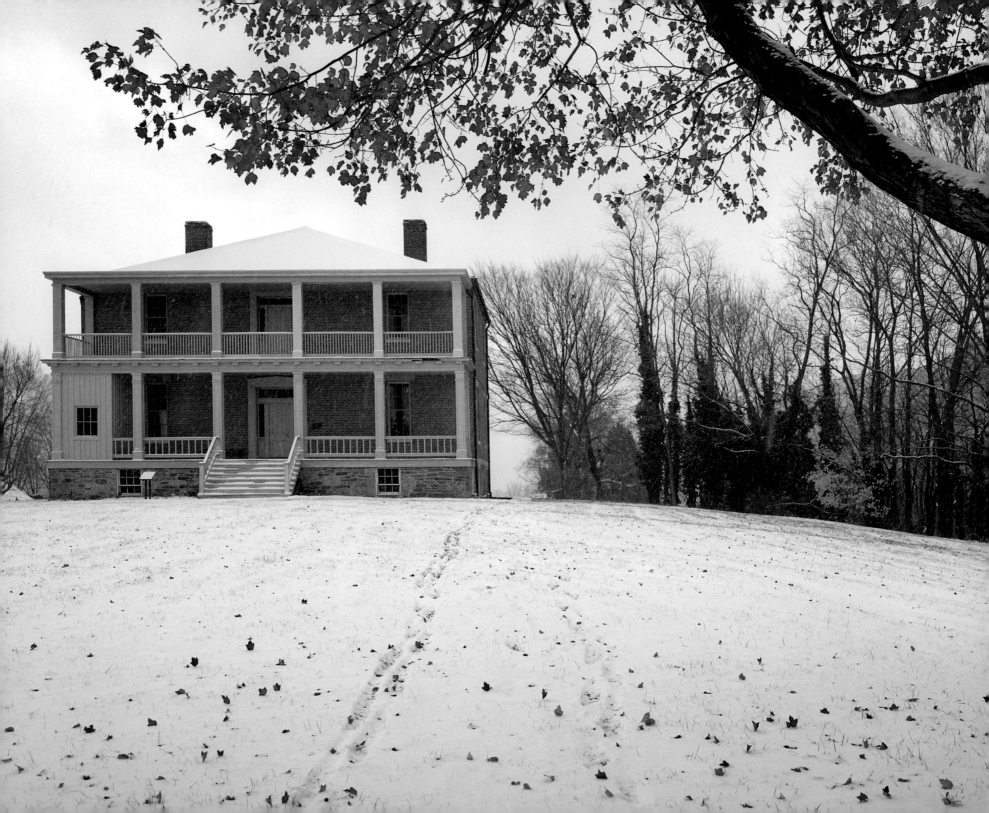

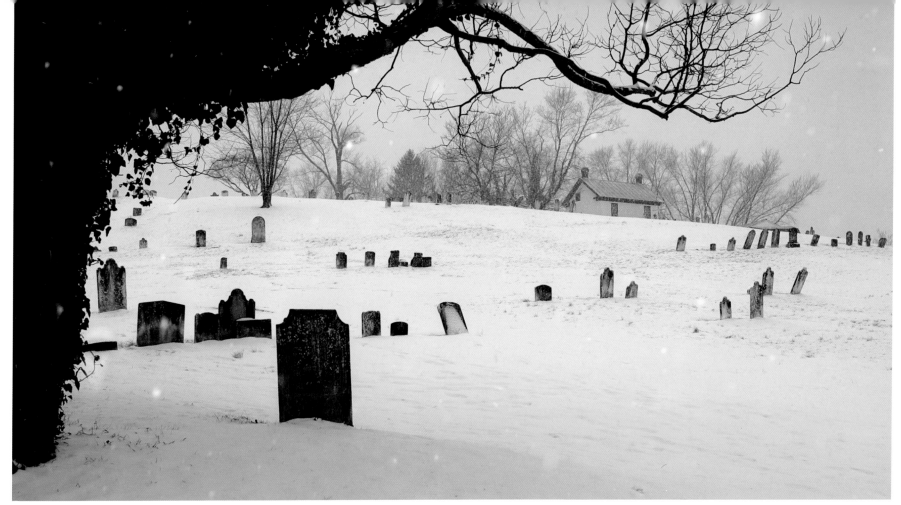

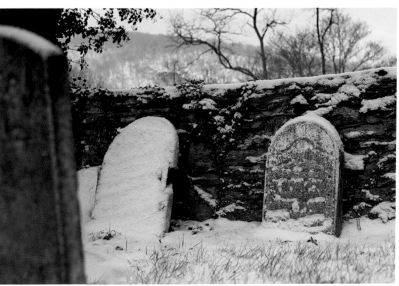

Bowing gracefully on a snowy hillside,
a brace of headstones mark 19th century graves in Harper Cemetery (right). Maryland Heights looms in the background. From the lower town, the cemetery is reached by climbing the very steep Stone Steps (far right). Hand-carved in the Harper shale, these old steps wind past St. Peter's and on up to Jefferson Rock. Just above here lies the cemetery, where the town's founder, Robert Harper, is buried beside his wife Mary (left). The settlement at the Ferry was very small when Mr. Harper died in 1782, which leads one to believe that Harper was an optimist as he set aside four acres of his land for the town cemetery (above).

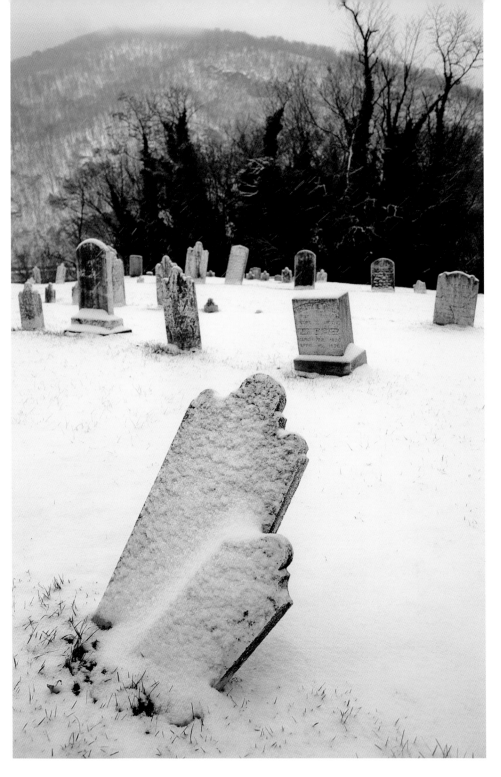

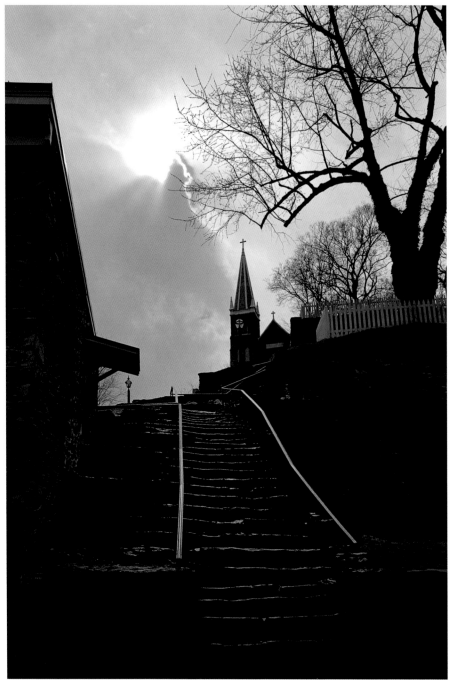

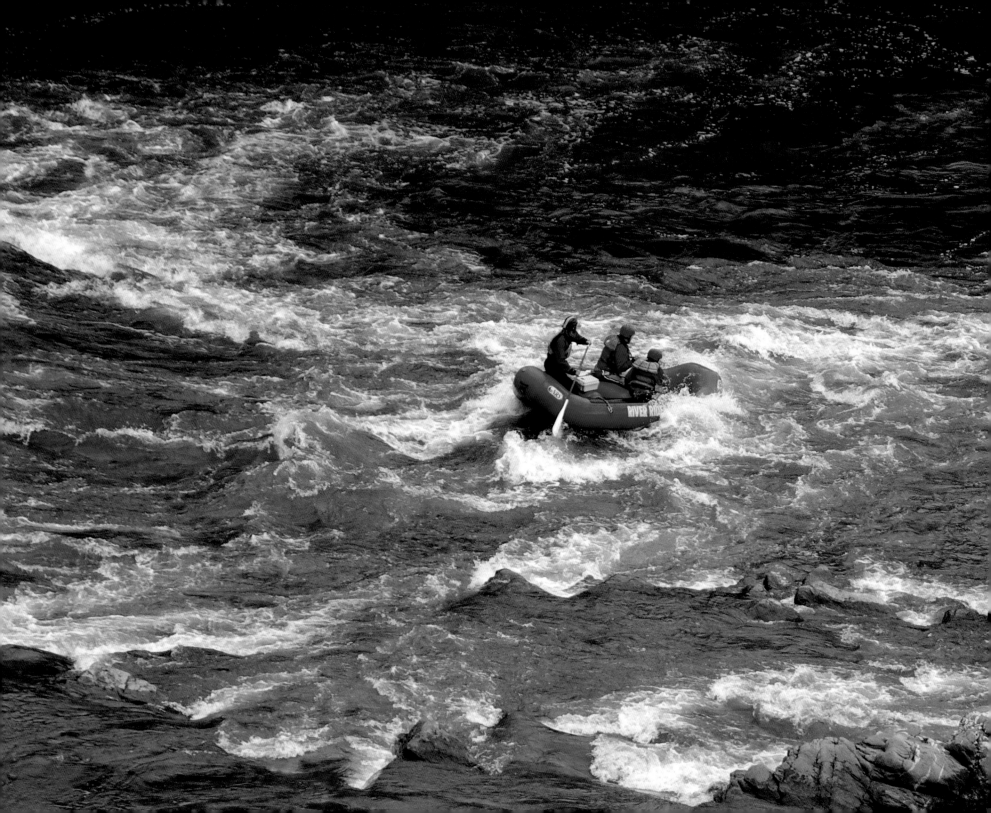

2

Two Great Rivers

The history of Harpers Ferry begins with the two great rivers that converge here, the Shenandoah and the Potomac. Long ago, these rivers joined forces and cut a gorge through the Blue Ridge Mountains. Native Americans and early explorers eagerly made use of this passage. Settlers soon followed. Robert Harper, a builder and millwright from Pennsylvania, was running a ferry service here by 1750. Barges were transporting iron, flour and lumber from the Shenandoah Valley by the time the Federal Armory began operation in the early 1800's. It was George Washington who saw the industrial potential of the Ferry, writing that the area possessed an "inexhaustible supply of water." As it turned out, there was often too much water, a fact not overlooked by engineers at the time. Washington prevailed over the objections of his engineers, and in 1799 construction of the Armory began. Before then, Harpers Ferry had served mainly as a gateway to the west. Afterwards, millwrights, entrepreneurs and speculators turned the place into an industrial mill town, drawing on the ample flow of the rivers. Water-powered mills operated into the 20th century despite being ravaged by the periodic floods that plague the Ferry. Today, the rivers are used for recreation. Kayaking, fishing, tubing, and white water rafting are all popular. As well, the rivers are a source of drinking water for many people living in the area.

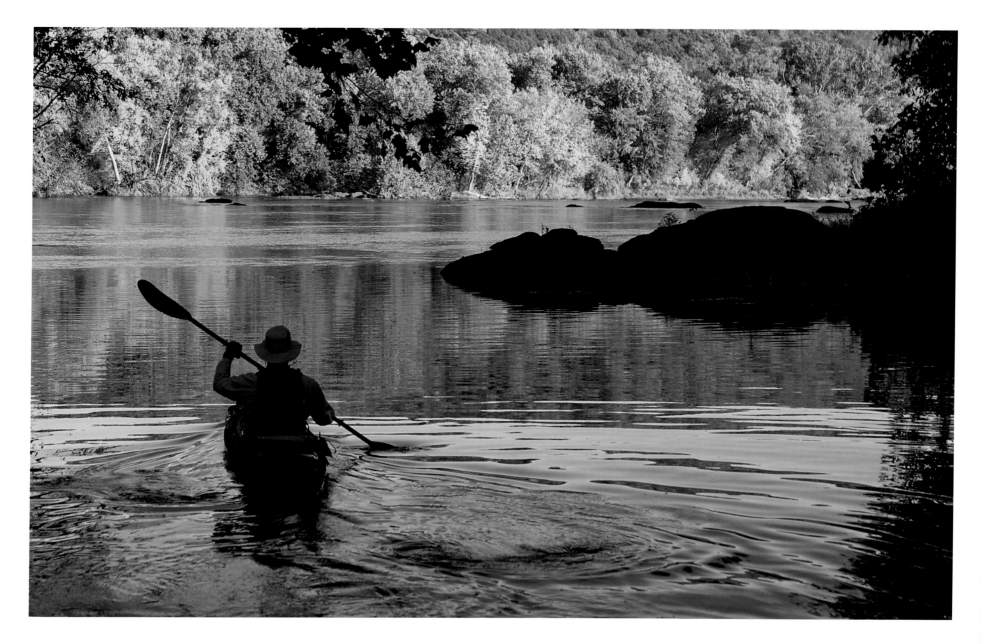

Early explorers were first attracted to Harpers Ferry by the passage through the mountains the rivers provided. Approaching the Ferry from the east on the Potomac, explorers of yesterday and today (above) pass through two water gaps. The first is through Virginia's Short Hill Mountain to the south and Maryland's South Mountain to the north. This long view of the second water gap (opposite) is looking west from Short Hill Mountain. The range to the south is the famed Blue Ridge and to the north is Elk Ridge. In the early 19th century, over 50 charcoal hearths were constructed on the ridge, producing fuel for nearby iron furnaces. Remnants of these hearths can be seen along hiking trails on Maryland Heights, which is the southern end of Elk Ridge and part of the National Park. By walking these steep trails, one appreciates just how vital the rivers were to explorers and early settlers.

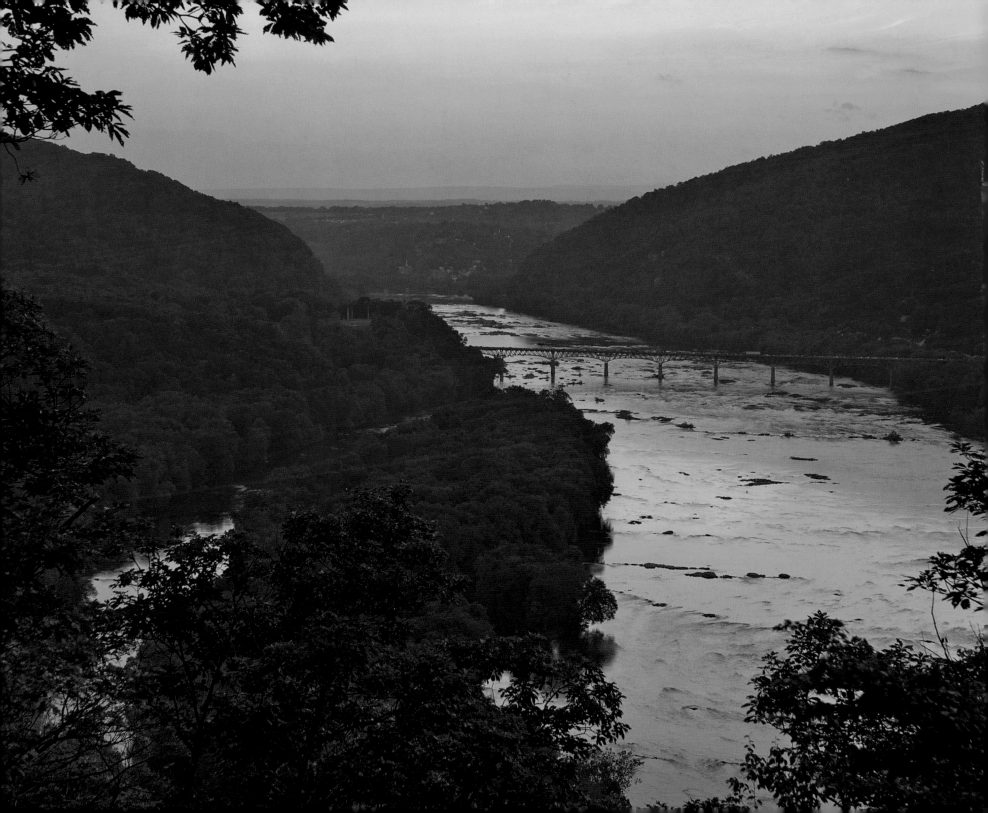

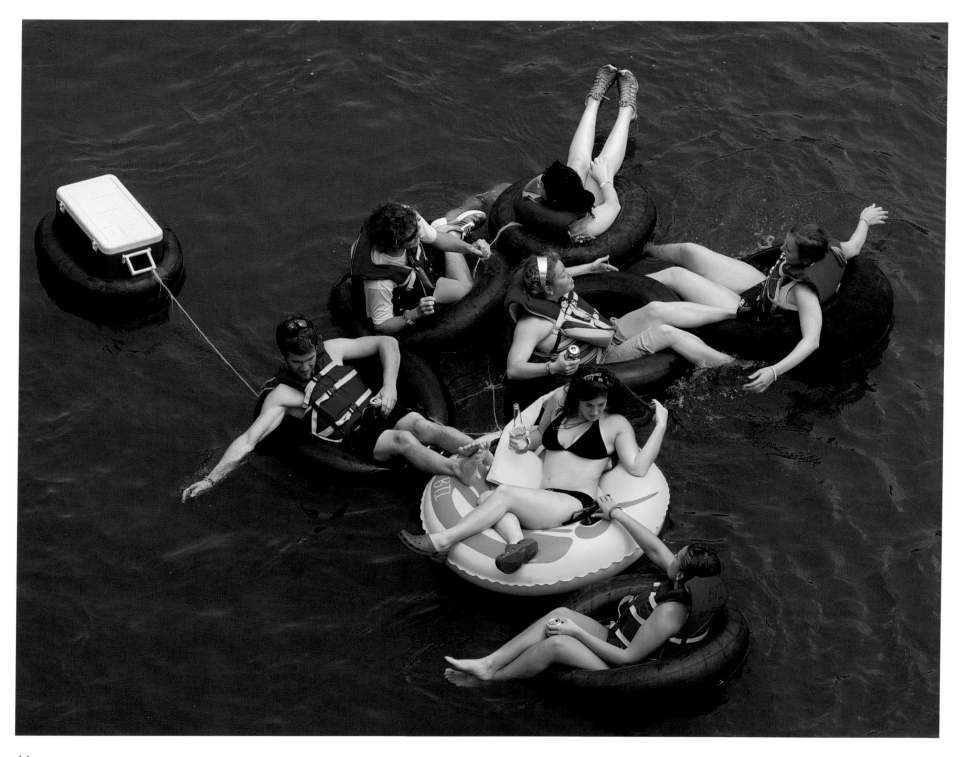

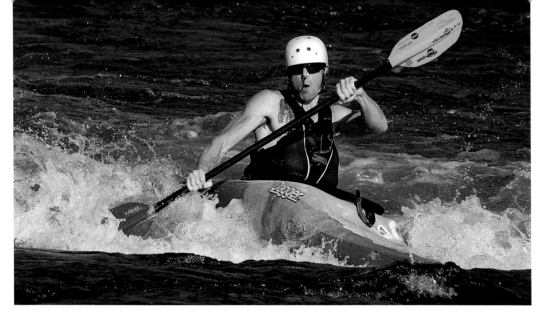

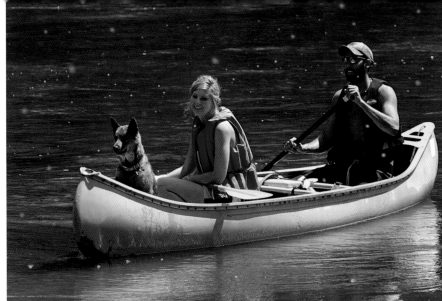

Enchanted by a flurry of cottonwood seeds, a couple and their dog glide along a placid Shenandoah River in the spring (above right). Today, enjoying the two rivers that shaped this landscape takes many forms. In the shadow of the Route 340 bridge, a lone fisherman wades the shallows of the Potomac, casting for smallmouth bass in the rocky pools (right). Kayaking, both white water and touring, is a pastime growing in popularity (above). Paddlers are challenged by class II and III whitewater. Favoring a more leisurely approach, college students float down a calm section of the Potomac River (opposite). Several outfitters rent tubes and offer shuttle service. Whitewater rafting is big business here. Recreation and tourism are the mainstays of the Harpers Ferry economy today, and the rivers provide one of the principal revenue streams.

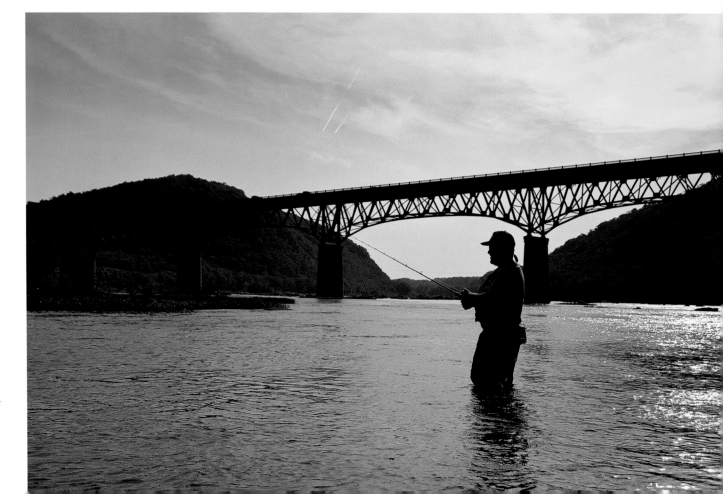

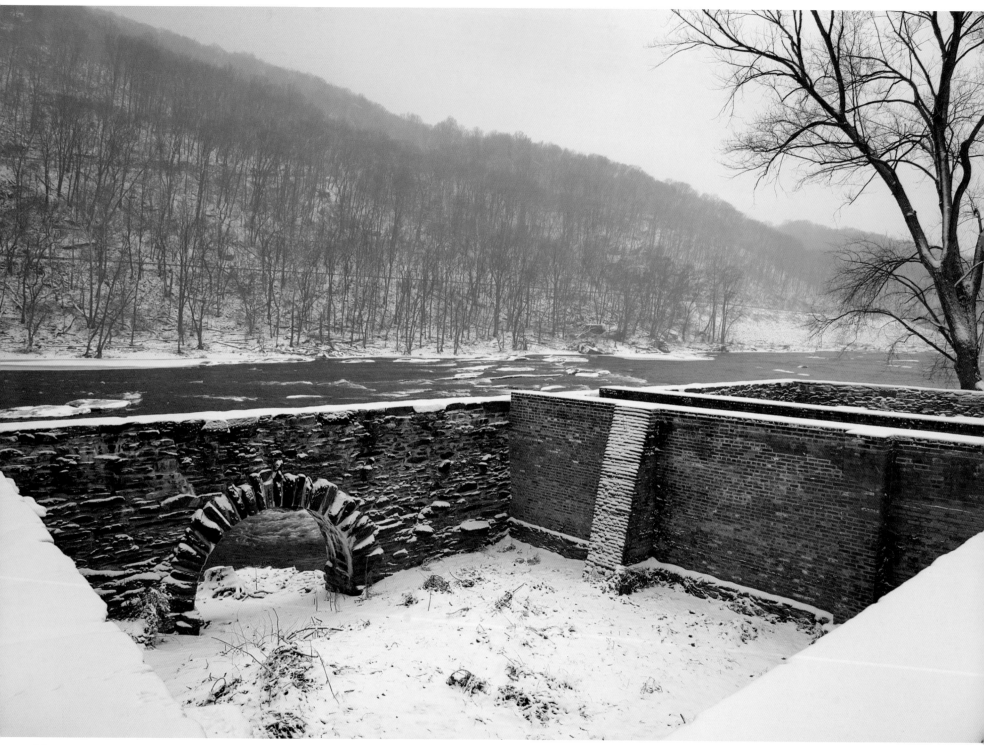

Virginius Island along the Shenandoah River was home to water-powered mills through most of the 19th century. Before the Civil War, the island had a flour mill, sawmill, granary, cotton mill, iron foundry, wagon-making shop, cooperage, and blacksmith shop. Today, some of the old mills have been partly restored, such as the cotton factory (opposite), its stone and brick facades standing in stark contrast to the fresh white snow of a winter day. The spinning frames and looms of the cotton factory were powered by iron water wheels. At times during the war, the factory served as a hospital. After the war, it was converted to a flour mill. A series of devastating floods eventually brought the mill town to its knees. The flour mill was one of the last to close, wrecked by the flood of 1889. Set back from the river, on the original site of the Shenandoah Canal's lower locks, lies the ruins of the Shenandoah Pulp Factory (right), built in the late 1880's. This mill was able to produce 40 tons of pulp per day and operated well into the 20th century. Today, these ruins represent the last of water-powered industry in Harpers Ferry. The Shenandoah Canal (above) was originally a natural channel that was widened and deepened in 1806 to allow cargo boats on the river to skirt the rapids. With the arrival of the railroad, the transport of goods by river became outdated. The canal was eventually incorporated into the waterpower system of Virginius Island's mills.

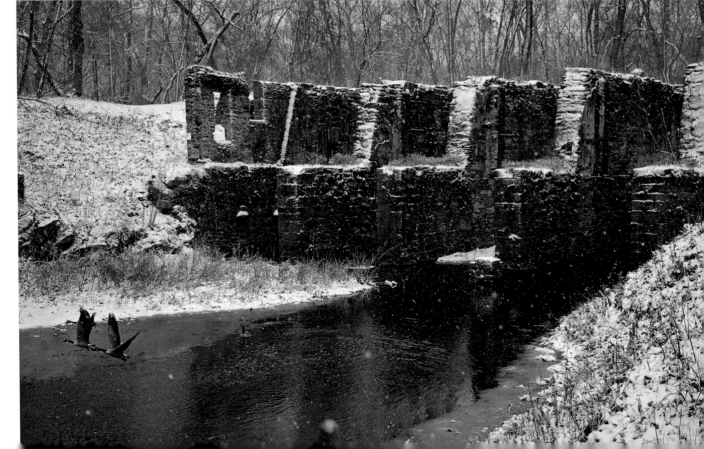

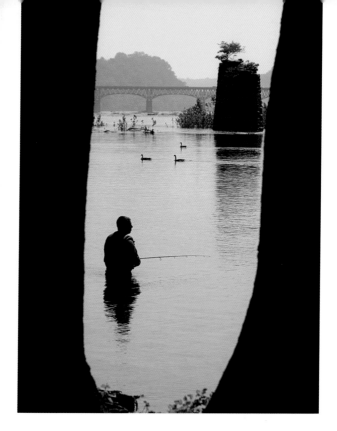

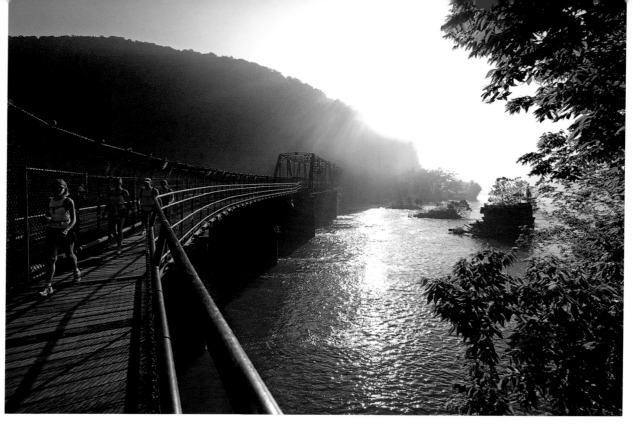

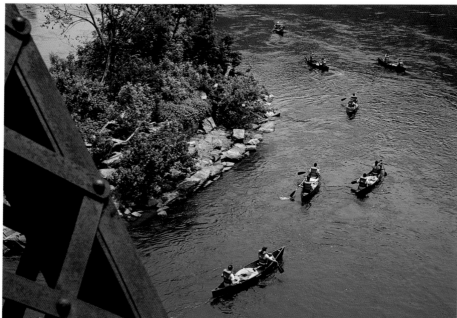

The first bridge at Harpers Ferry was constructed in 1824, "a handsome double wooden highway bridge" across the Potomac. It was built by the Wager family, who had inherited Robert Harper's land and ferry service. Pedestrians and wagons were charged a toll to cross. The B&O Railroad built a second bridge in the 1830's, and later bought out the Wagers. The B&O's bridge gave passage to wagons and horseman as well as their trains. During the Civil War, this vital link to Washington and points east was destroyed and rebuilt nine times. Ruins of the old bridge remain, but they are slowly disappearing. Today, two railroad bridges cross the Potomac at Maryland Heights, near the convergence with the Shenandoah (opposite). A pedestrian walkway (above) runs along one of them, allowing easy access between the town and the hiking trails on Maryland Heights. Part of the Appalachian Trail, the walkway is a great place to watch the traffic on both the rivers and the rails (left). Cars and trucks cross the Potomac about a mile downriver from the town (above left). Also visible is one of three stone piers that are remnants of a wagon bridge built in 1882, replacing the first Shenandoah bridge, which spanned the river 300 yards upstream. The first bridge was destroyed by Confederate raiders in 1861. The second one was taken out by a flood in 1889. When this bridge was destroyed yet again in the flood of 1936, ferry service returned to the town and operated for many years.

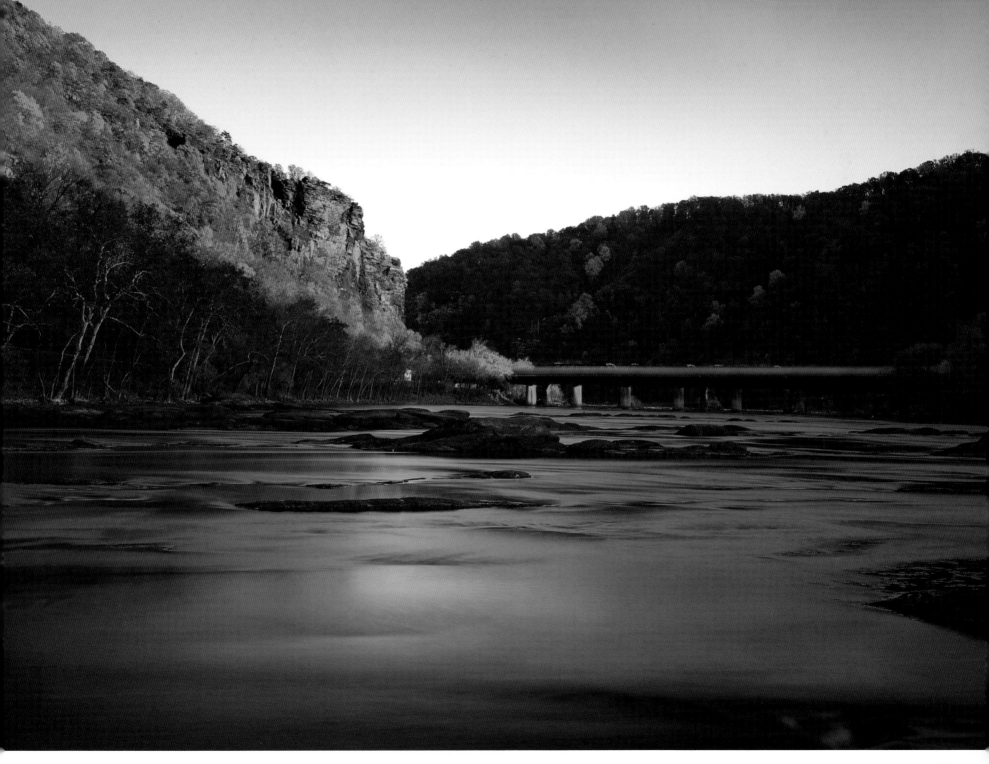

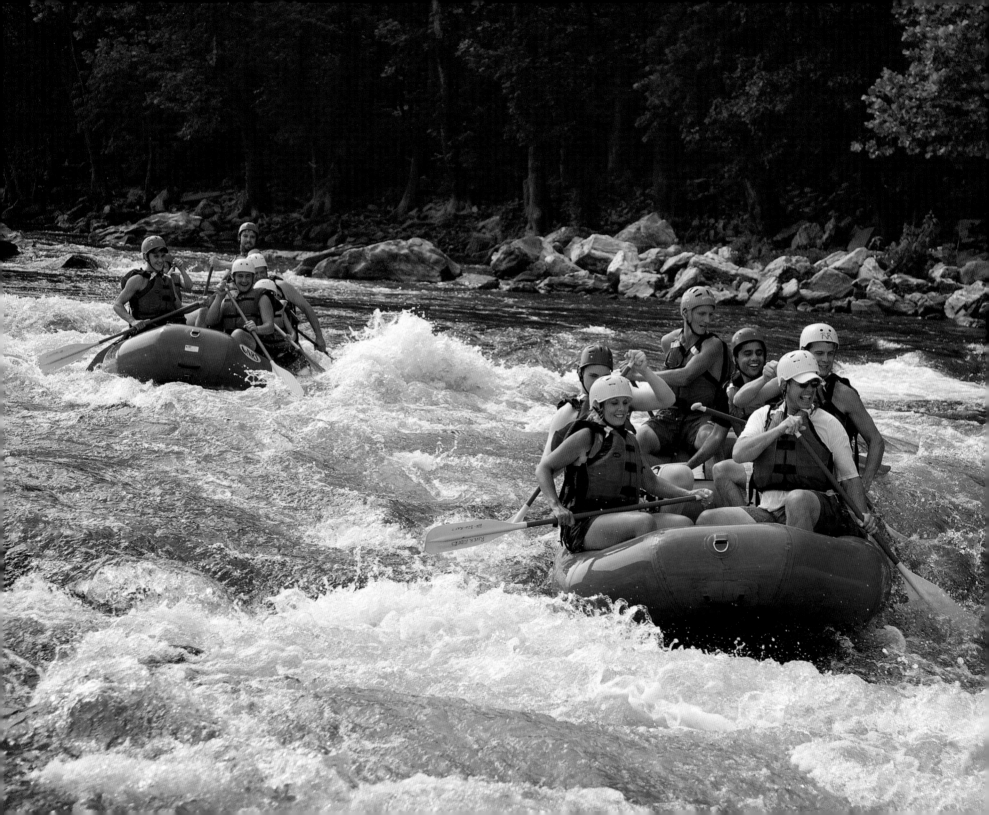

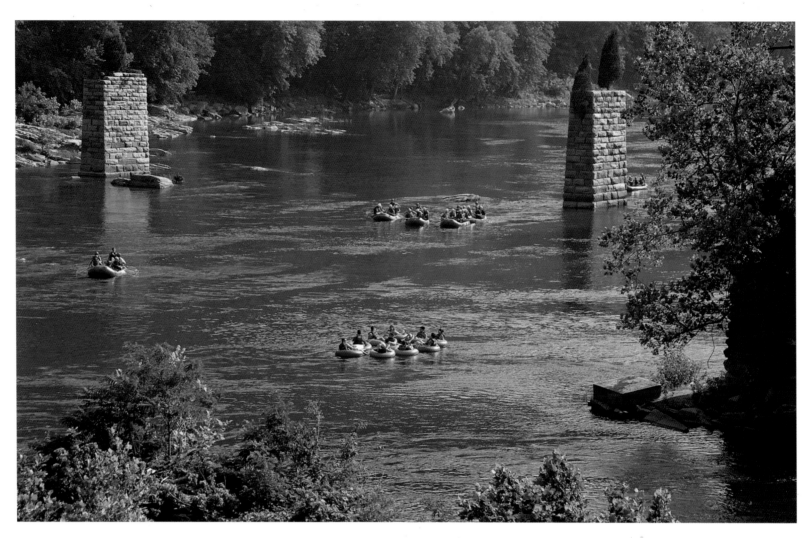

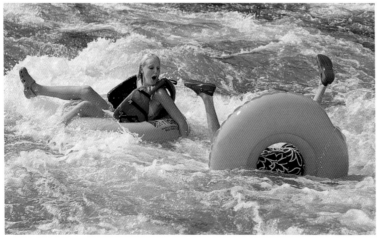

The rollicking White Horse Falls on the Potomac is a favorite with rafting and tubing parties alike (left). Years ago, when the river was used to transport freight, such rapids were avoided when ever possible. In some places, skirting canals built by the Patowmack Company were used. On a calm section of the Shenandoah River near The Point (above), a flotilla of rafts pass by the stone piers of an old bridge whose wooden spans were washed away in the Great Flood of 1936. These piers stand like sentries at the mouth of the Shenandoah. Just down river from here, the rafts merge into the Potomac, where a tubing party is already cruising the strong currents of the mighty river.

51

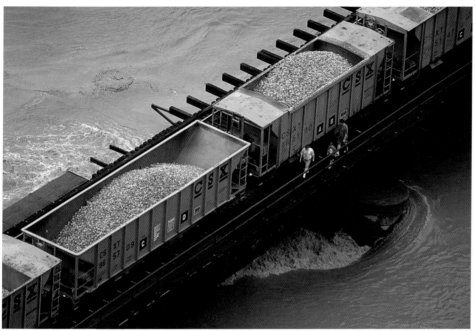

To ensure the railroad bridges spanning the Potomac River are not swept away, hopper cars loaded with gravel were positioned on the tracks during the September flood of 1996. Despite the danger these unruly rivers posed, people walked along the bridges to have a closer look at the power of the floodwaters. Kayakers paddled the high waters of the Shenandoah, which inundated the lower town. The rivers have both powered and plagued Harpers Ferry throughout its history. The most devastating flood came in 1870, when all the key industrial structures of Virginius Island were either damaged or destroyed. More tragic still, 42 residents lost their lives when they were trapped by the fast-rising waters. The highest recorded flood was in 1936, when the water crested at 36 feet. Two bridges were lost in that flood. The rivers crested at almost 35 feet in the flood of 1889, which took out the Shenandoah wagon bridge and forced the Child & McCreight flour mill to close for good. In comparison, the rivers crested at 29 feet in 1996. But this happened twice, once in January after torrential rains followed on the heels of a big snowstorm, and then again in September, marking the first time in the town's history that two major floods occurred in the same year.

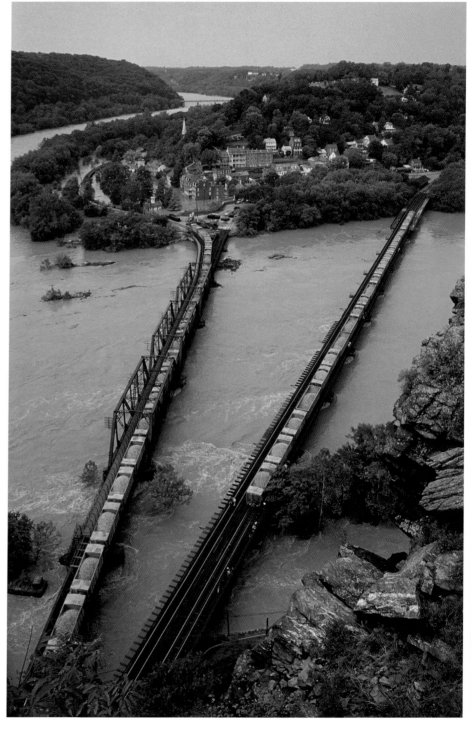

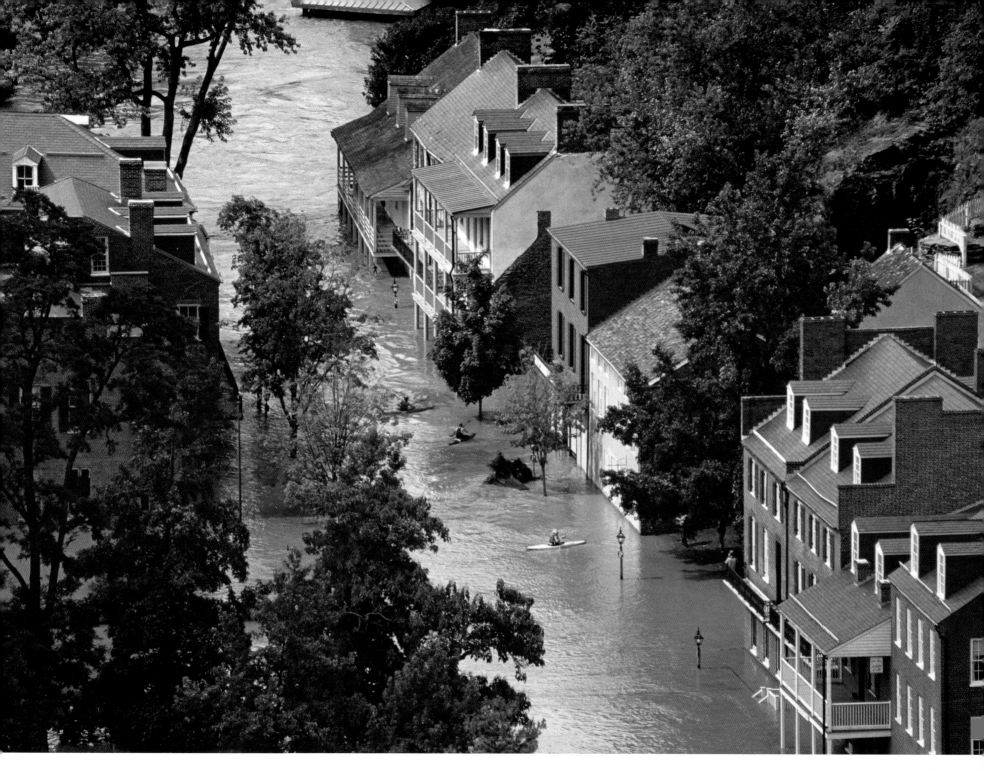

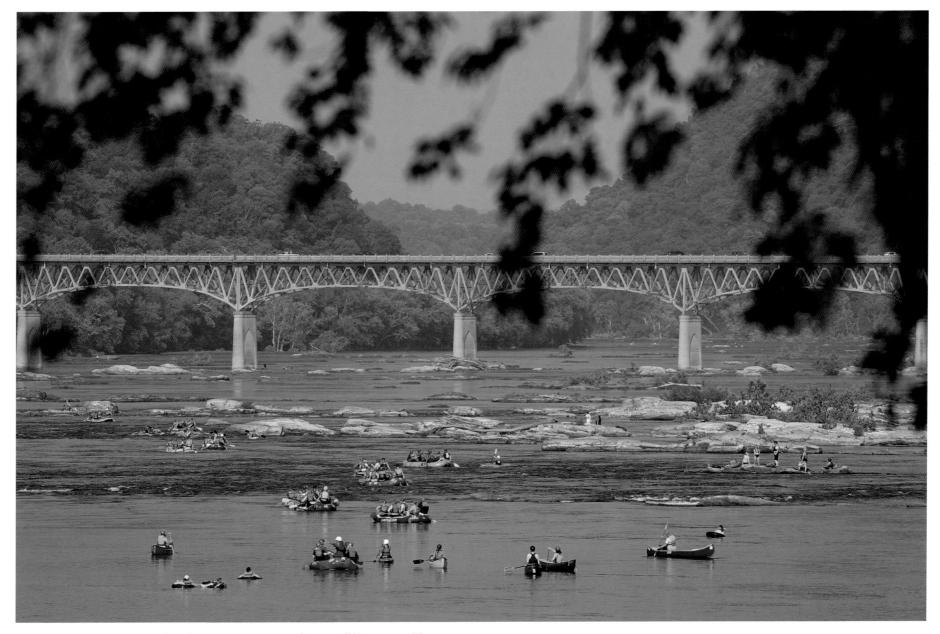

At the height of a busy summer day at Harpers Ferry (above), the air is steamy, the water level low, and the sluggish rivers crowded. In early spring, the Shenandoah is a different place altogether (opposite). The mood of a spring river is nothing like that of a lazy summer day. In the springtime, the water flows high and fast, and early morning fog is quite common. Running along Virginius Island, this section of the Shenandoah is named The Staircase for the ledges of Harpers shale that create a series of class II rapids. The ledges attract small mouth bass, which hang out in the eddies formed by the rocks. This stretch of river is a favorite with both fisherman and kayakers. Paddlers are drawn to the ledges, too, but for an entirely different reason. They enjoy surfing the waves formed by the rocky structures.

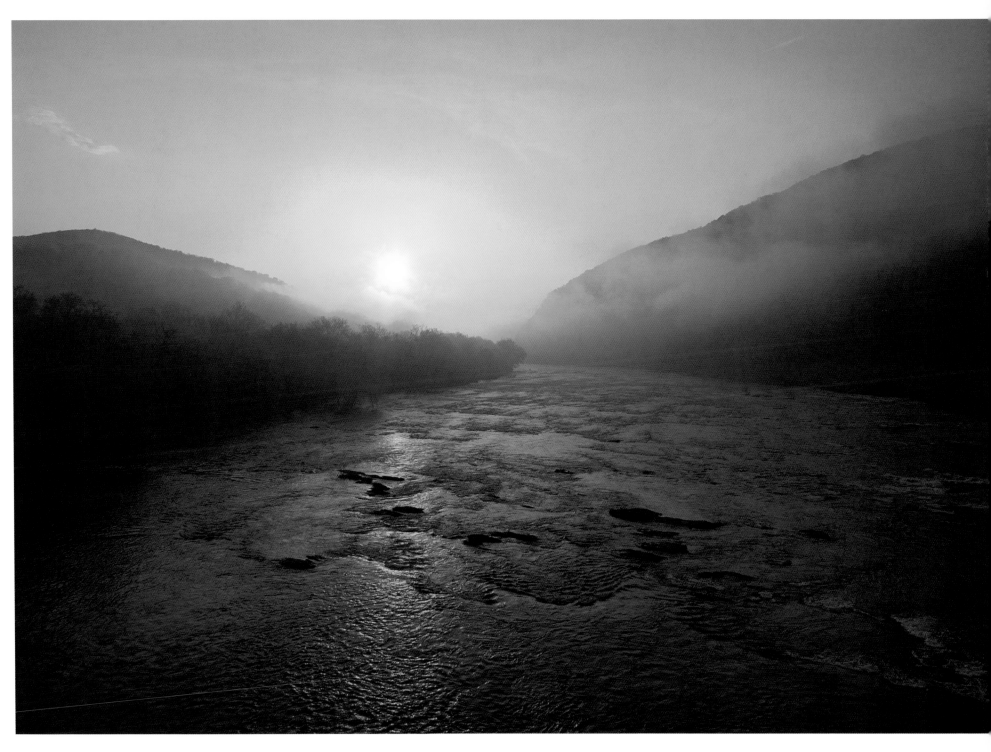

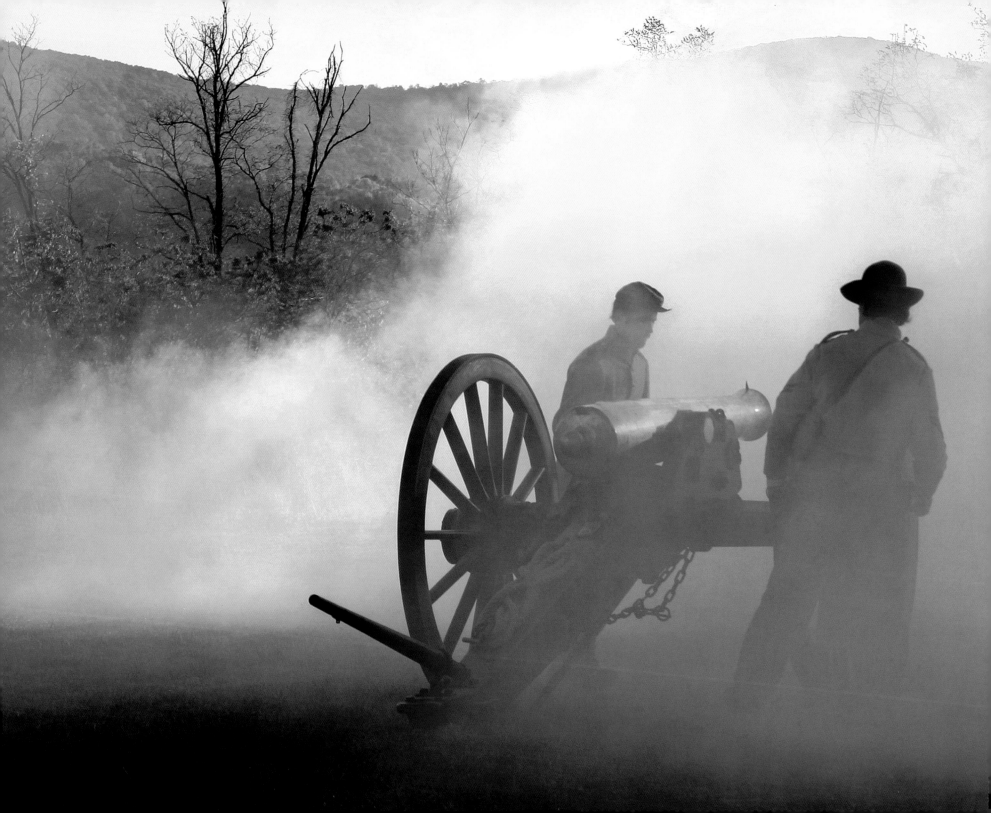

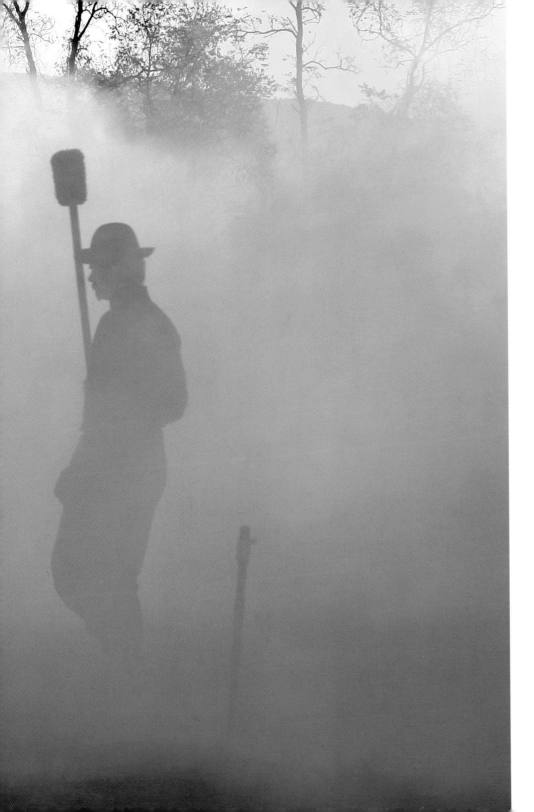

3

The War Years

Stonewall Jackson said of Harpers Ferry, "I'd rather take that place fifty times than undertake to defend it once." On the eve of the Battle of Antietam, Confederate General Robert E. Lee ordered Jackson to take Harpers Ferry to secure his supply lines to Virginia. In this three day engagement known as the Battle of Harpers Ferry, Jackson's army first had to gain control of the ridges surrounding the town. Surprisingly, Maryland Heights was the only fortified ridge, and the seasoned rebel troops easily ran off the green Federals. Unable to use horses or mules because of the steep terrain, soldiers had to haul their cannons up the sheer mountain slopes. Finally, with their guns positioned on the ridges, the Confederate artillery bombarded the lowly garrison into submission. In the end, over 12,000 Union troops surrendered. Not until World War II would a surrender of U.S. troops of such magnitude be equaled. Hard though it was to defend, Harpers Ferry was strategically important to both armies. The rail lines were part of the attraction, but also the town's location. To the northern armies, Harpers Ferry was the gateway to the Shenandoah Valley. To the armies of the south, the town was a back door passage to Washington. By war's end, Harpers Ferry had changed hands eight times.

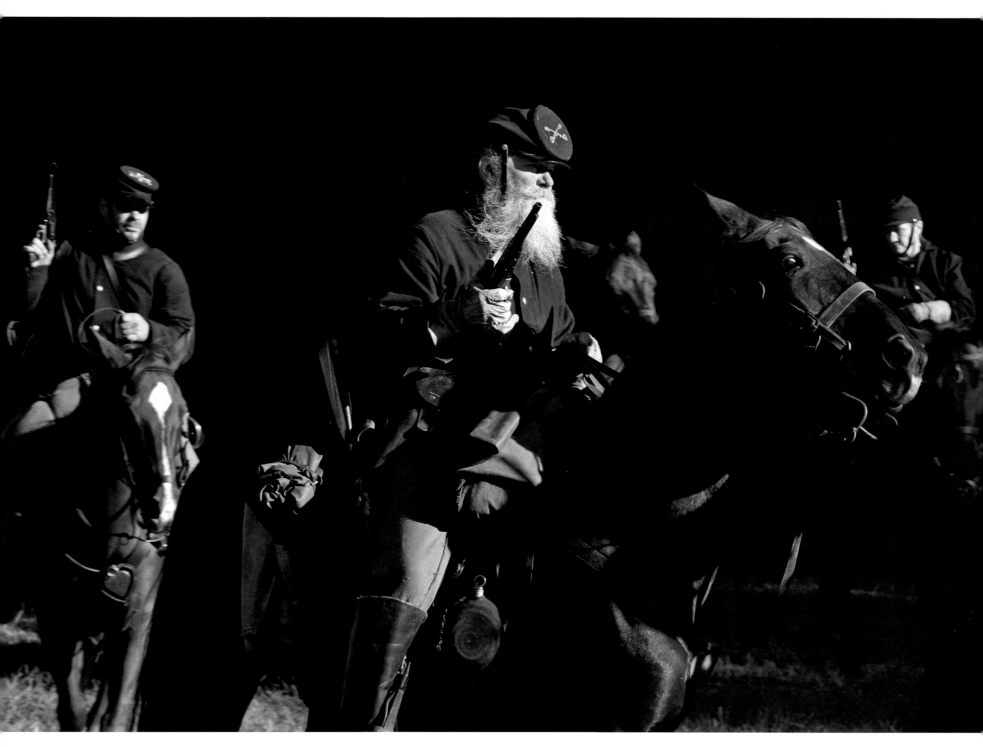

On the eve of Jackson's artillery barrage of the Union garrison at Harpers Ferry in September of 1862, a cavalry column of 1500 men led by Colonel "Grimes" Davis managed to escape across the Potomac on a pontoon bridge. On their way to Sharpsburg, the Union cavalry captured 91 Confederate ammunition wagons. When the cavalry turns out today, volunteer horsemen demonstrate weapons firing and saber drills. Many of the living history programs are centered on the Civil War years. Its location and railroad lines made Harpers Ferry important to both Union and Confederate forces. By the spring of 1862, most of the town's people had fled. Churches and mills were used as hospitals. Soldiers were quartered in abandoned homes, and in some cases, houses were even used to stable horses. In a letter home from Harpers Ferry, one soldier wrote "the entire place is not actually worth $10." But to the opposing armies, the Ferry was worth fighting for. Union forces at the Ferry served to protect an important transportation corridor, mainly the B&O Railroad, but also the C&O Canal and the roads leading into the Shenandoah Valley. And the town served as a supply base for operations in the Valley. With Jackson's division on the move in the area, the Valley became a major battleground during the first full year of the war.

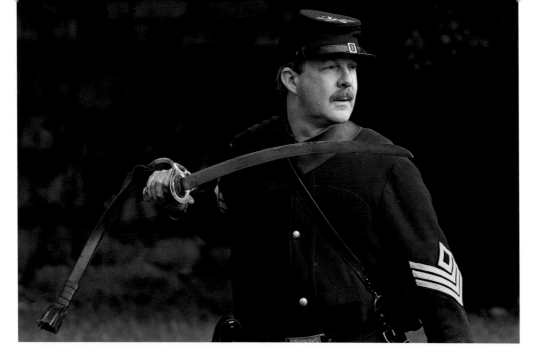

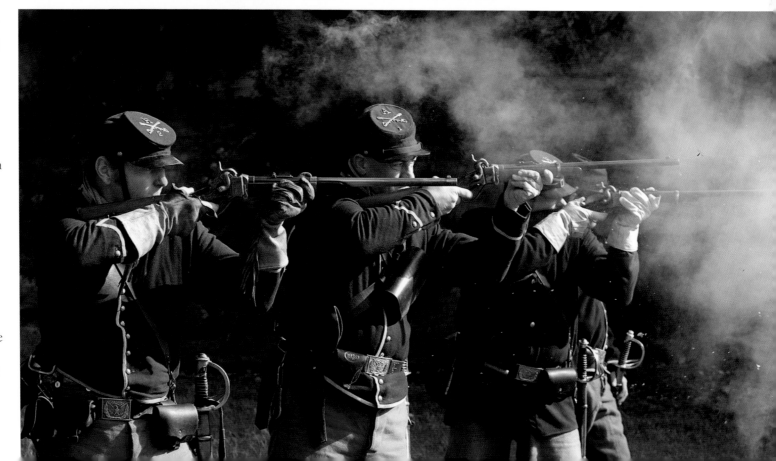

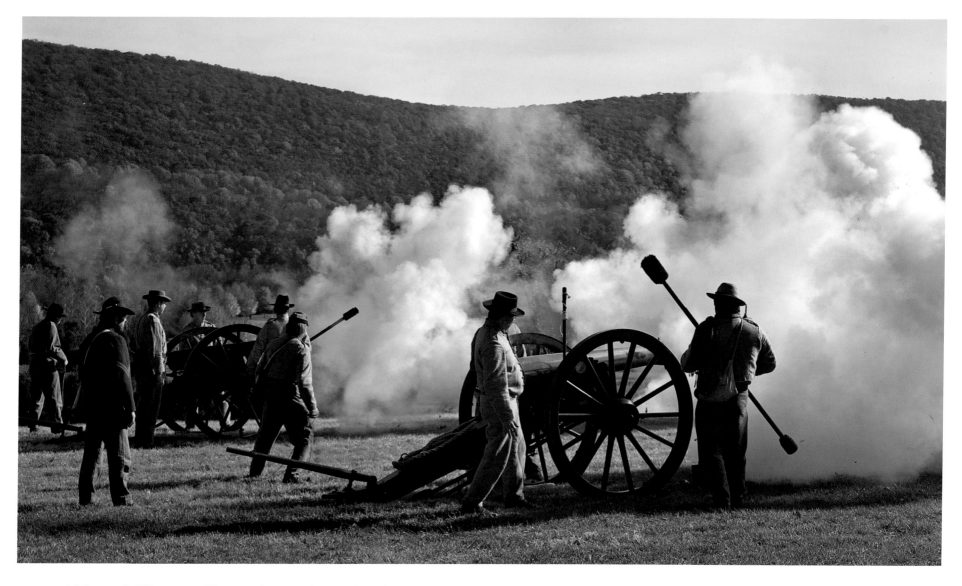

Although Harpers Ferry changed hands often over the course of the war, confederate forces did not occupy the town for long. The one exception was right after the war began. Several companies of Virginia militia advanced on the Ferry in April, 1861, running off the small garrison of Federals. Thousands of volunteers soon followed. Colonel Thomas Jackson, an instructor at VMI, was ordered by the Governor of Virginia to take command at Harpers Ferry. Jackson spent the next six weeks assembling and drilling the volunteers, most of whom were from the Shenandoah Valley. Five Virginia regiments became the First Brigade of the Army of the Shenandoah under the command of Jackson, who was soon promoted to brigadier general. These troops would soon be known as the Stonewall Brigade. Before leaving Harpers Ferry, Jackson had the armory equipment shipped south, along with locomotives and rail cars. What the confederates didn't take, they destroyed. They burned the remaining Armory buildings and Hall's Rifle Works. Jackson also ordered the demolition of the B&O railroad bridge over the Potomac. Water towers were toppled and boats smashed. Barge traffic on the C&O was blocked by rubble dumped into the canal. By the time Jackson departed, much of the town lay in ruins.

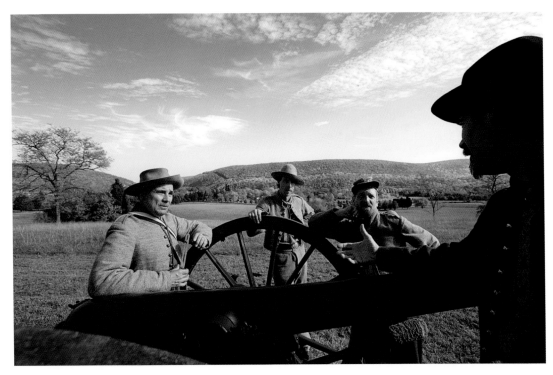

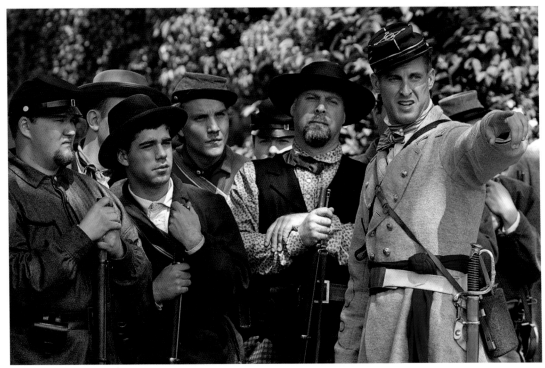

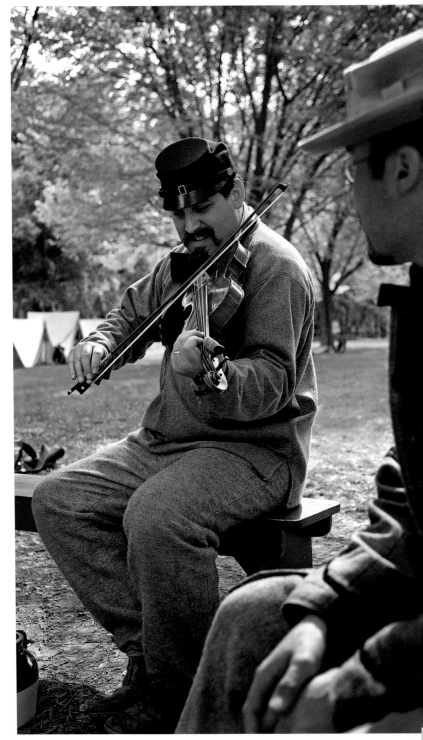

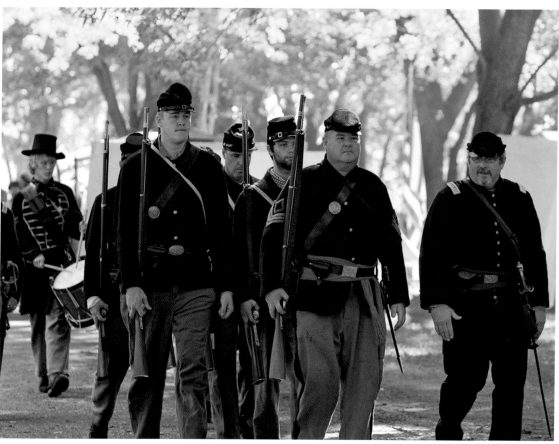

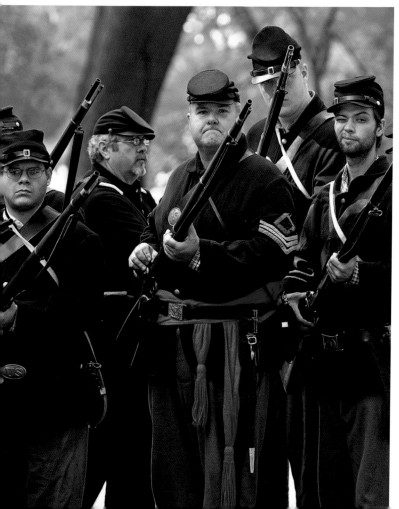

After the Battle of Antietam, the massive Army of the Potomac marched into town, and the troops pitched their tents on Camp Hill and Bolivar Heights. Following the bloodiest single day of fighting in American history, Lincoln had ordered General George McClellan to take possession of the Ferry and make it a permanent base. Once the town was garrisoned, Lincoln fully expected McClellan to keep moving south in pursuit of Lee. But "Little Mac" lingered in Harpers Ferry, occupying his time with rebuilding the Potomac River bridge and fortifying the heights surrounding the town. Lincoln said of McClellan, "He's an admirable engineer, but he seems to have a special talent for a stationary engine." The troops occupied their time with daily drills, target practice down by the Shenandoah, and bathing in the shallow river. Some officers brought their wives to town. Joseph Barry, a resident of Harpers Ferry, compared the camps to "two villages aglow with hundreds of watch lights." Like other residents, Barry was glad the Union army was there to protect person and property, but lamented the "drunken rioting among the troops." The army stayed through most of the autumn of 1862. Even a visit by Lincoln could not get McClellan moving again. Finally in November, the Army of the Potomac pulled up stakes and headed south, but ever so slowly, covering only six miles a day. McClellan was soon relieved of his command by a frustrated Lincoln.

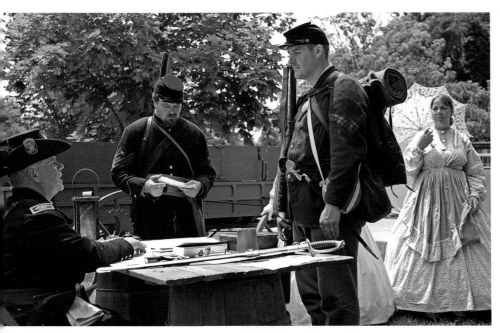

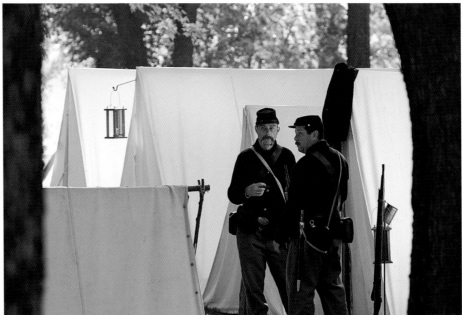

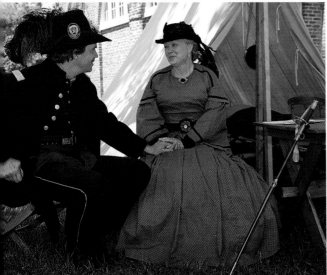

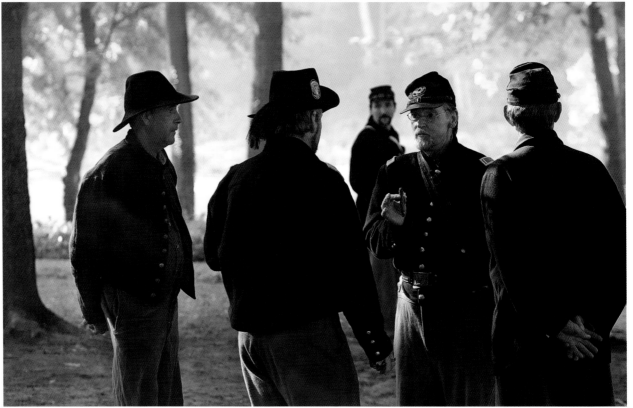

The cast of characters who take part in the special programs at the Ferry are made up of both volunteers and park staff, all of whom share a passion for Civil War history (overleaf).

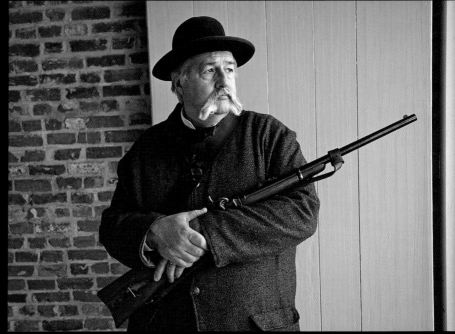
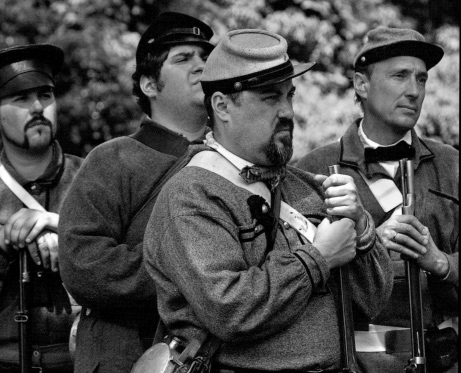

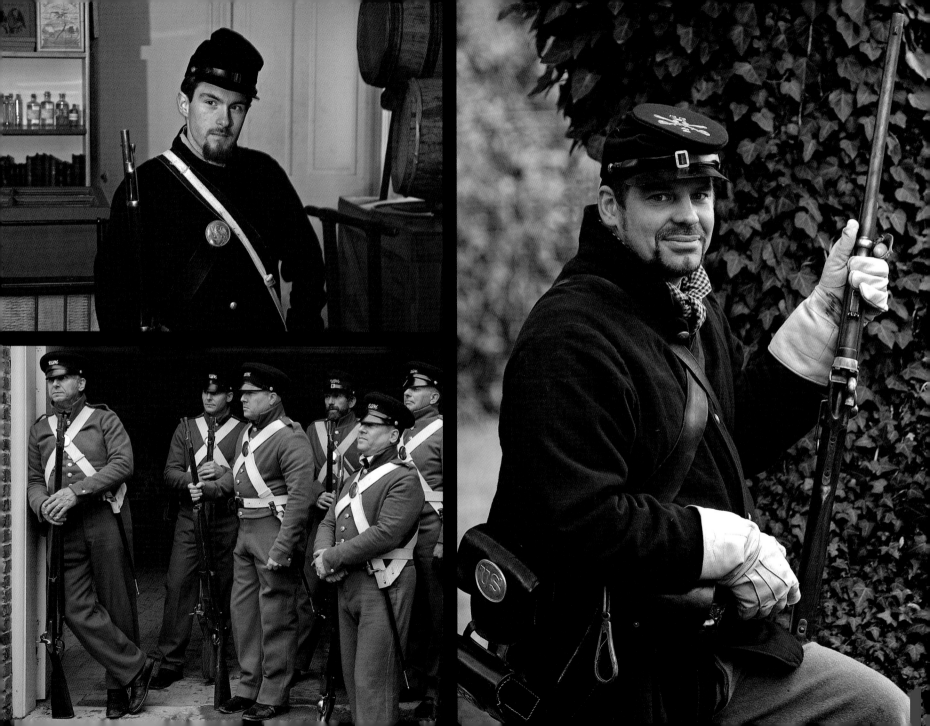

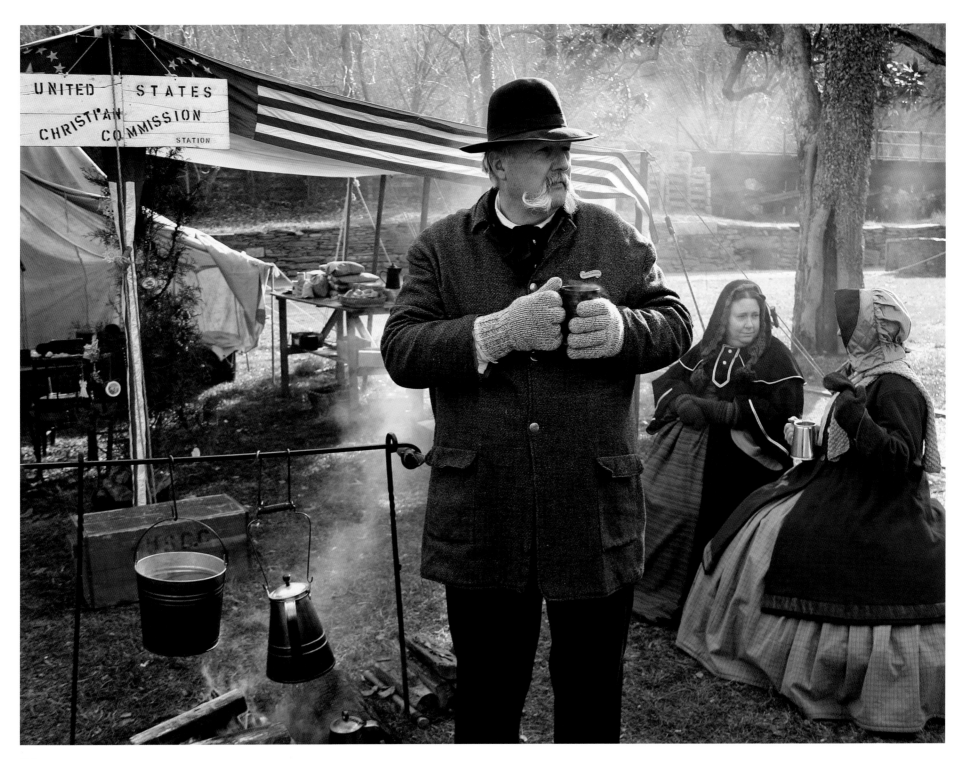

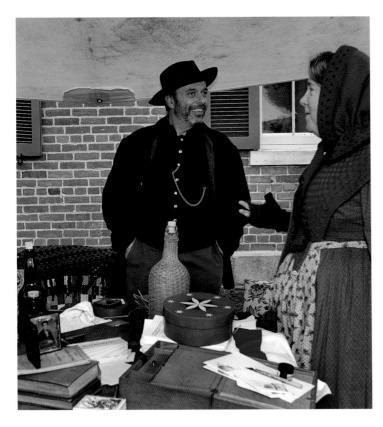

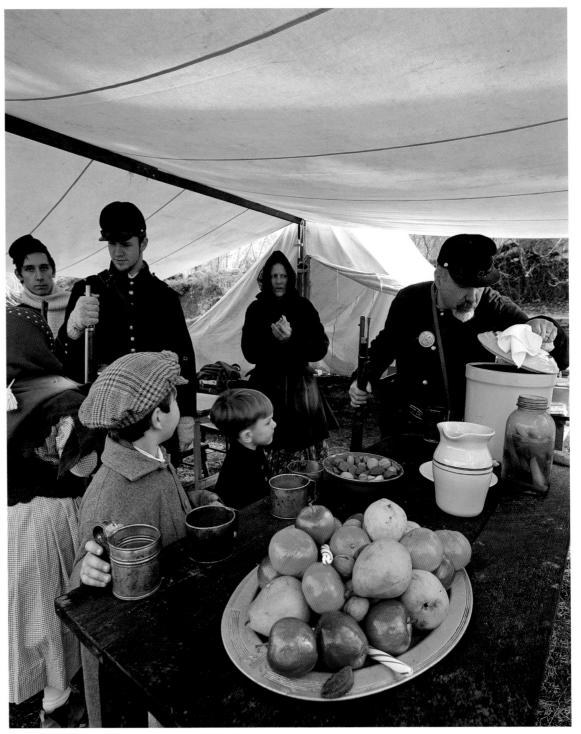

Writing home from Harpers Ferry, one soldier described the place as a "godforsaken, stinking hole." Camp life during the war was no picnic. In fact, the biggest killer of the Civil War was disease, and the filthy conditions of many camps were to blame. In response, the U.S. Sanitary Commission was formed. A civilian organization, its mission was to provide supplies to Union soldiers and to work with the Army in promoting good health in the ranks. Another wartime organization, the U.S. Christian Commission, was affiliated with the YMCA. The Commission was originally formed to address the spiritual needs of soldiers as few camps had chaplains. But the group soon expanded its work, providing for the physical and social needs of soldiers as well. The Commission's tents became social centers, where delegates gave out stationary and periodicals, operated lending libraries and canteens, and distributed food, clothes and medical supplies.

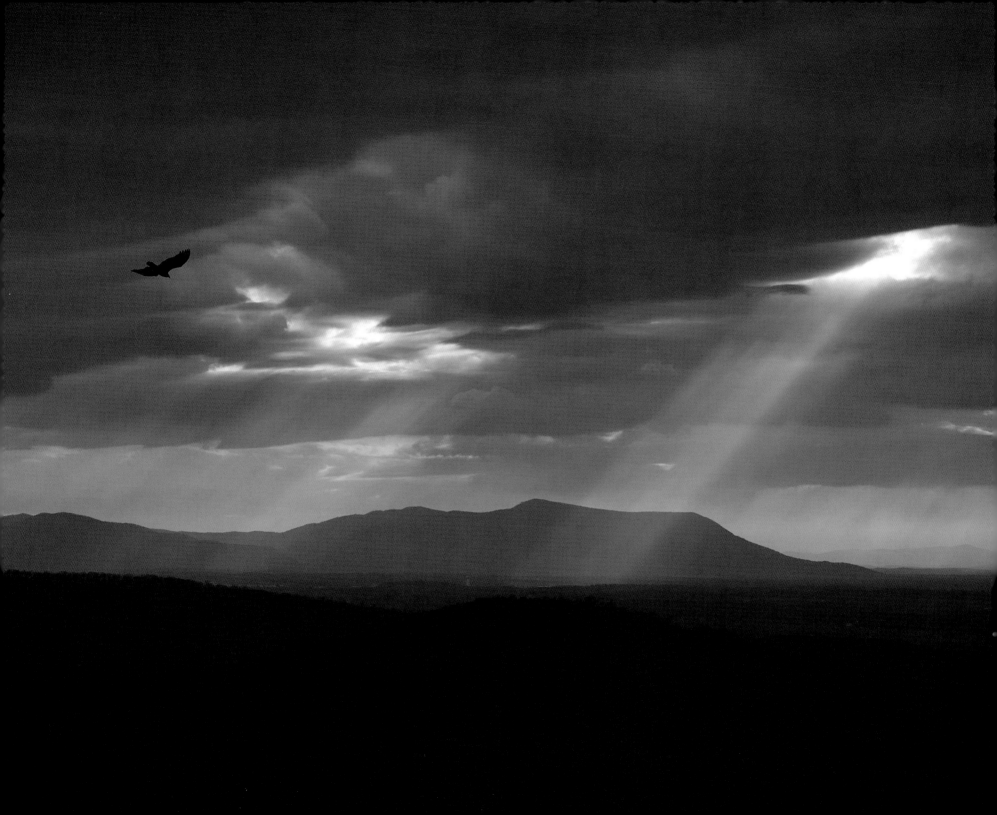

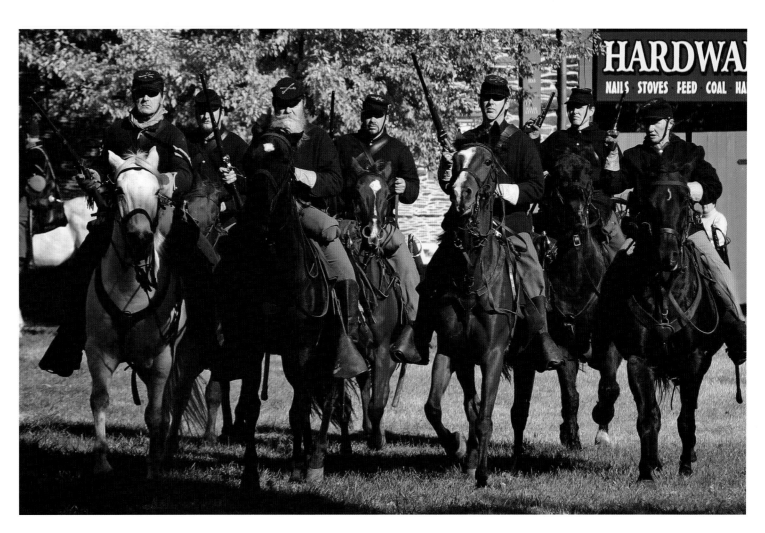

Sheridan's orders from Grant were explicit. Headquartered at Harpers Ferry in August of 1864, Union General Philip Sheridan was charged with defeating the Confederate army in the Shenandoah Valley (the view, left, is from the AT south of town). Moreover, General Ulysses Grant ordered Sheridan to destroy this important agriculture valley of the south so thoroughly "that crows flying over it for the balance of the season will have to carry their own provender." Grant wanted the valley rendered useless to the Confederates. For the past three years, the Shenandoah Valley had proved strategically important to the rebel army, providing safe harbor and serving as its breadbasket. In the summer of 1864, with his Army of the Potomac dug in around Petersburg, Grant concluded that Washington would never be safe so long as Confederate troops remained in the Valley. In July, General Jubal Early, the cagey commander of the rebel forces in the Shenandoah, had already made one thrust at Washington, briefly occupying Harpers Ferry in the process. By September, Sheridan had slowly gathered the men and supplies he needed. With a final nudge from Grant, he began his Valley Campaign. Locally known as "The Burning," Sheridan's cavalry moved through the valley, destroying crops, burning barns, and carrying off livestock and slaves. Portending the scorched earth tactics of Sherman, the Valley Campaign marked the first major use of this type of warfare. The campaign succeeded. By the end of the year, Early's army had been crushed and the Shenandoah Valley lay in ruins. Washington was never again threatened.

The widow Cornelia Stipes ran a boarding house in Harpers Ferry during the Civil War. It was customary for merchants to rent out rooms and apartments above their stores. These lodgings were often operated by women. Many weekends find the war years at the boarding house brought to life by volunteer reenactors. On the second floor, rooms occupied by a military officer and war correspondent James Taylor are on display. Taylor was studying art in New York when the war began. He enlisted with the 10th New York Volunteers and served for two years, making sketches of army life in his spare time. He eventually became a sketch artist and war correspondent for Leslie's Illustrated and was assigned to follow Sheridan's army. Taylor was with Sheridan when the general was at Harpers Ferry and throughout the Shenandoah Campaign of 1864.

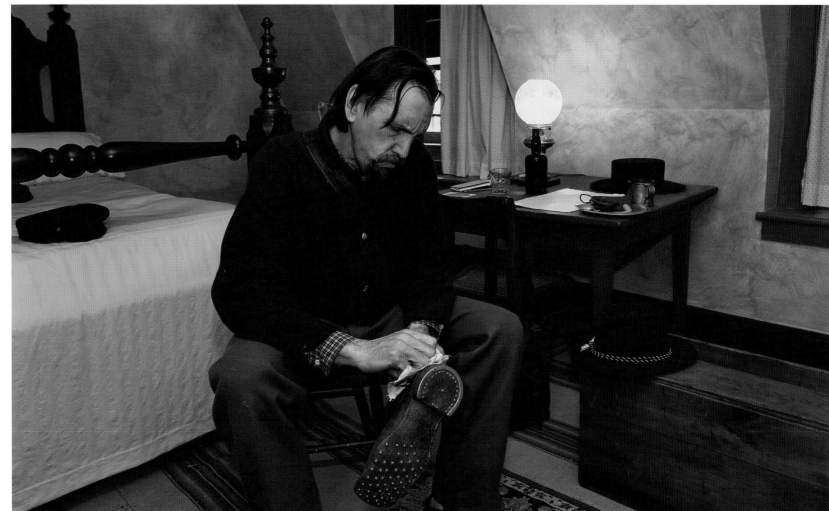

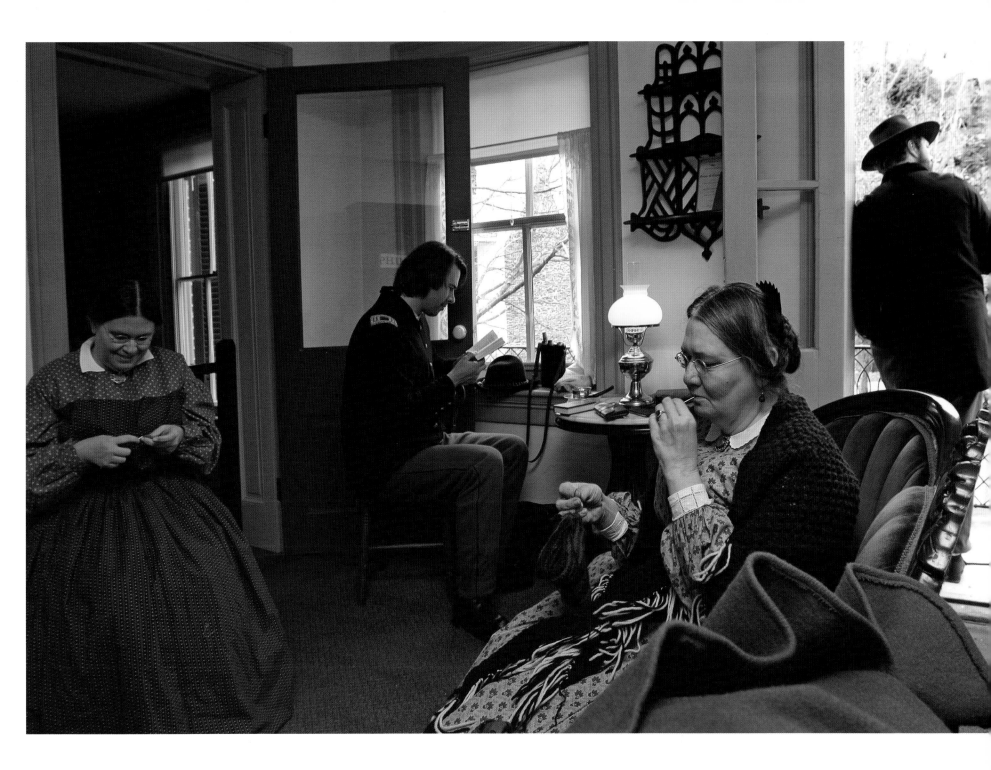

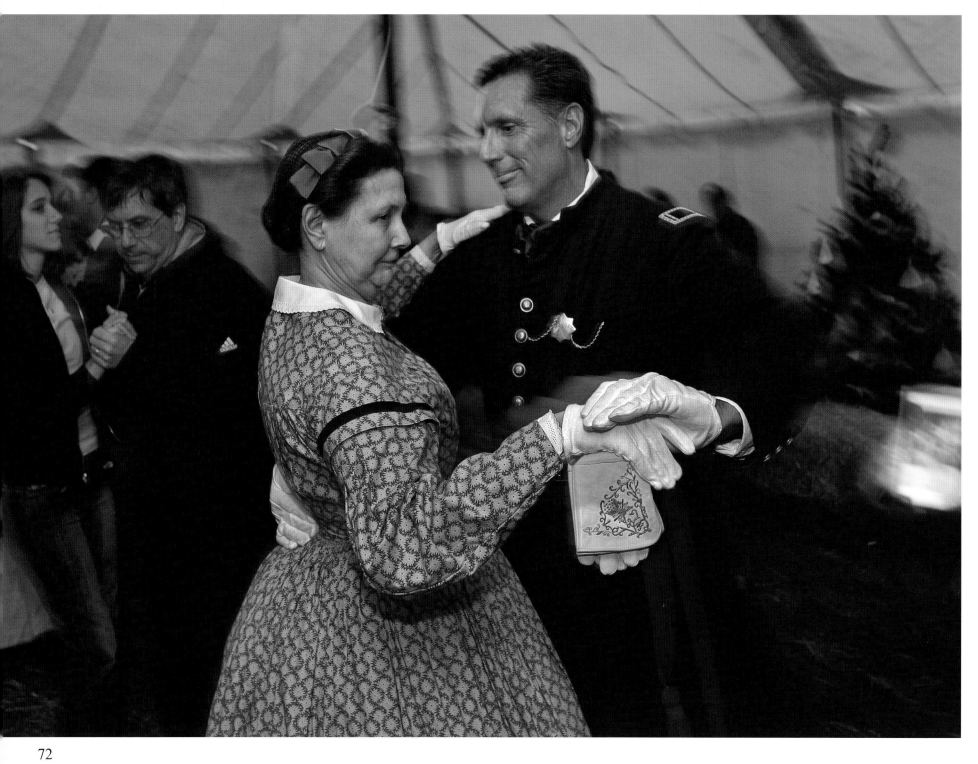

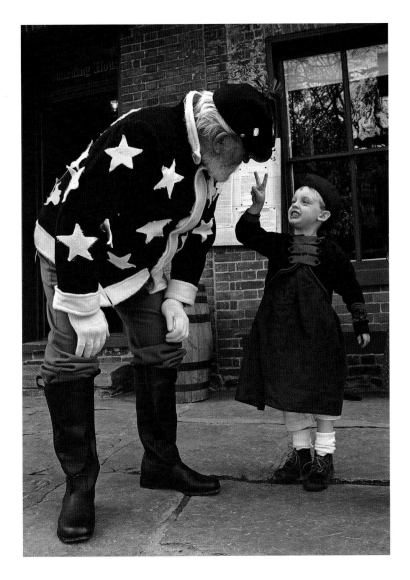

Soldiers on the battlefront in Harpers Ferry created their own version of Christmas, and each December the park service stages a special program focusing on Yuletide 1864. Local citizens and soldiers prepare for the Yuletide (right), while a Civil War style Santa Claus greets a child (above). In a reenactment of a Victorian Cotillion, visitors join with volunteer reenactors in dancing to live music performed with 19th century style instruments (opposite).

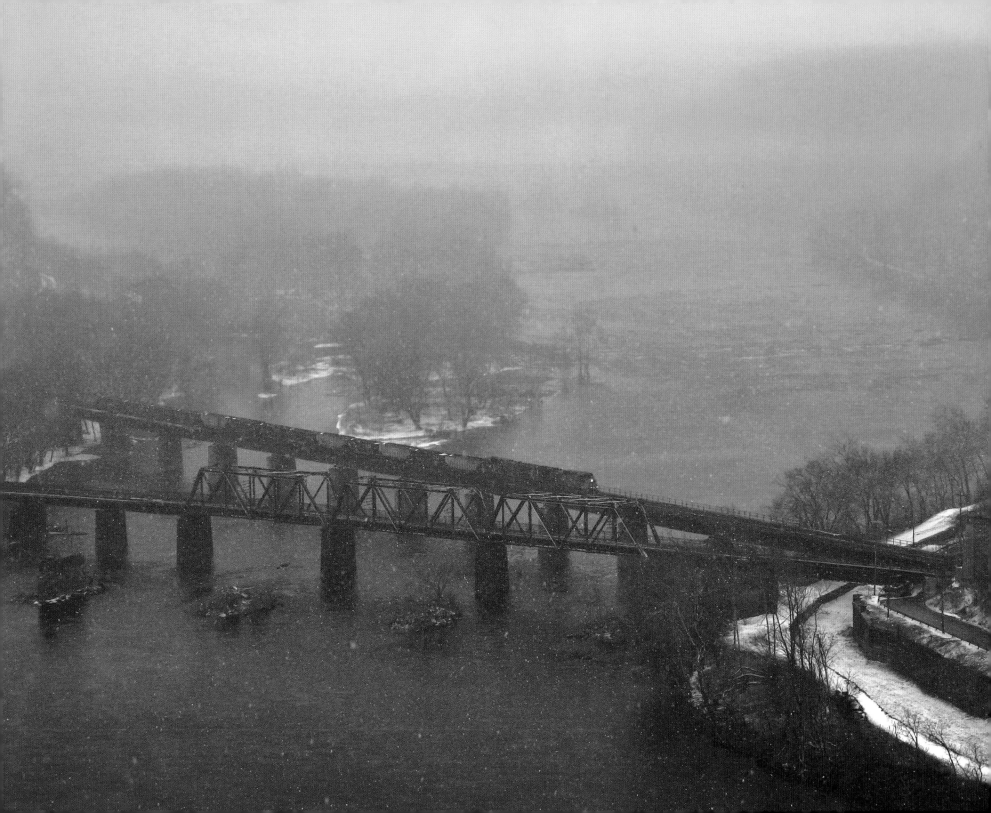

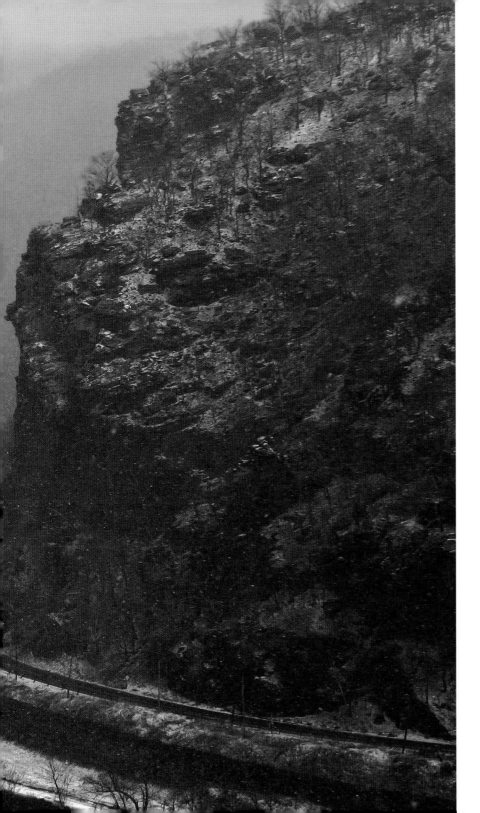

4

On The Move

In the 19th century, America was on the move like never before. The Baltimore & Ohio Railroad and the Chesapeake & Ohio Canal broke ground on the same day in 1828. Along with the Winchester & Potomac Railroad, the three transportation lines converged on Harpers Ferry in the mid-1830s. The water gap through the mountain ranges that had eased the passage of explorers and early settlers now opened Harpers Ferry and the west to economic expansion. For the next twenty years, the town experienced an industrial boom. Bridges soon replaced the ferry service that Robert Harper had started in the mid-1700s. Established in 1785, the Patowmack Company and their first president, George Washington, helped to promote commerce by improving navigation on the rivers and building a series of skirting canals, allowing shallow-draft river boats to bypass dangerous rapids and falls. Stagecoach service was another means of travel between Washington and the Ferry. Today, only the railroads remain active. The rail lines still pass through the famed gap, along with U.S. Route 340.

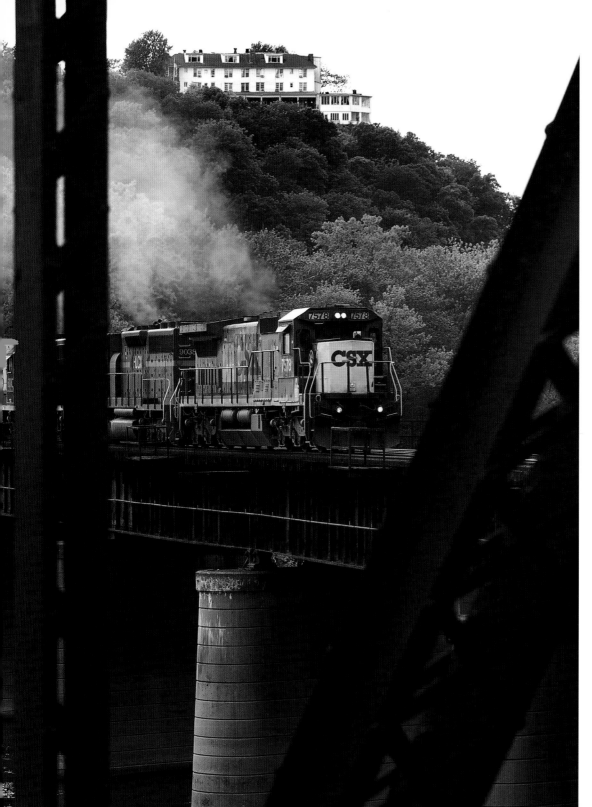

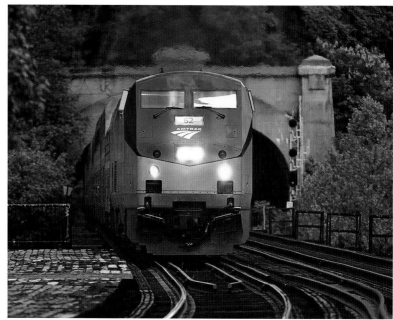

The trains that pass through Harpers Ferry are a loud and clear reminder of the town's transportation history. More than any other form of transportation, it was the railroad that drove economic expansion in the 19th century town. The role of Harpers Ferry in opening up the west was coupled to the steam trains that hauled the necessary raw materials, workers, and finished goods. By the 1850's, thousands of tons of coal were transported through the Ferry each month, headed to eastern seaports. That hasn't changed. Today, trains seem to pass through the town hourly, many hauling coal. Traveling the old Baltimore & Ohio line (left) a CSX train crosses the Potomac into Maryland. Running along an elevated track that traverses the southern edge of the lower town (above right), a freight train moving east from a local quarry passes very close to one of the restored buildings in the park. A locomotive pulling empty hopper cars heads back to coal country (far right). Passenger trains are also a regular sight, such as this Amtrak train emerging from the Maryland Heights tunnel (above). Both Amtrak and MARC have daily stops at the Harpers Ferry train station (right). Recently renovated, the train station was originally built in the 1890's near The Point where the rivers meet. It was moved to its current location in 1931.

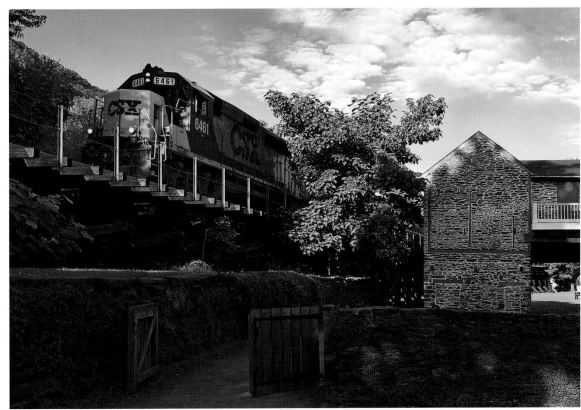

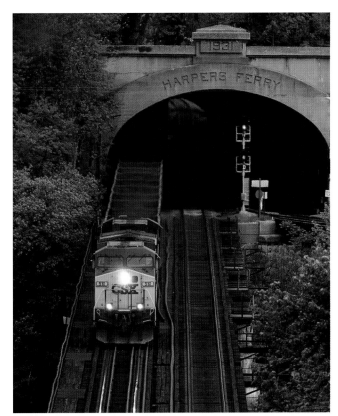

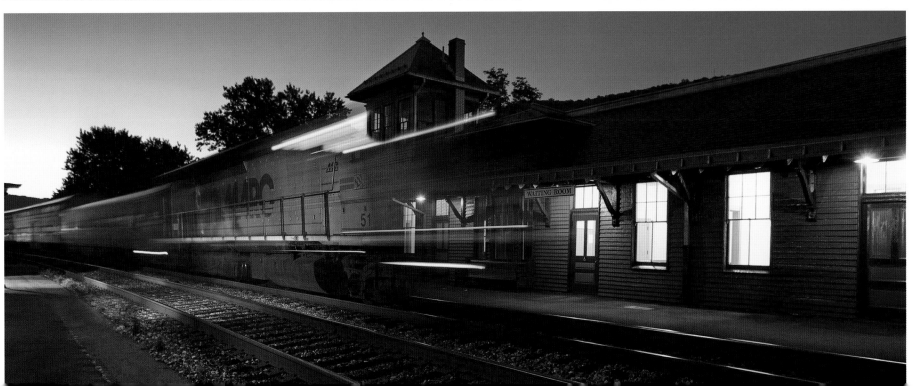

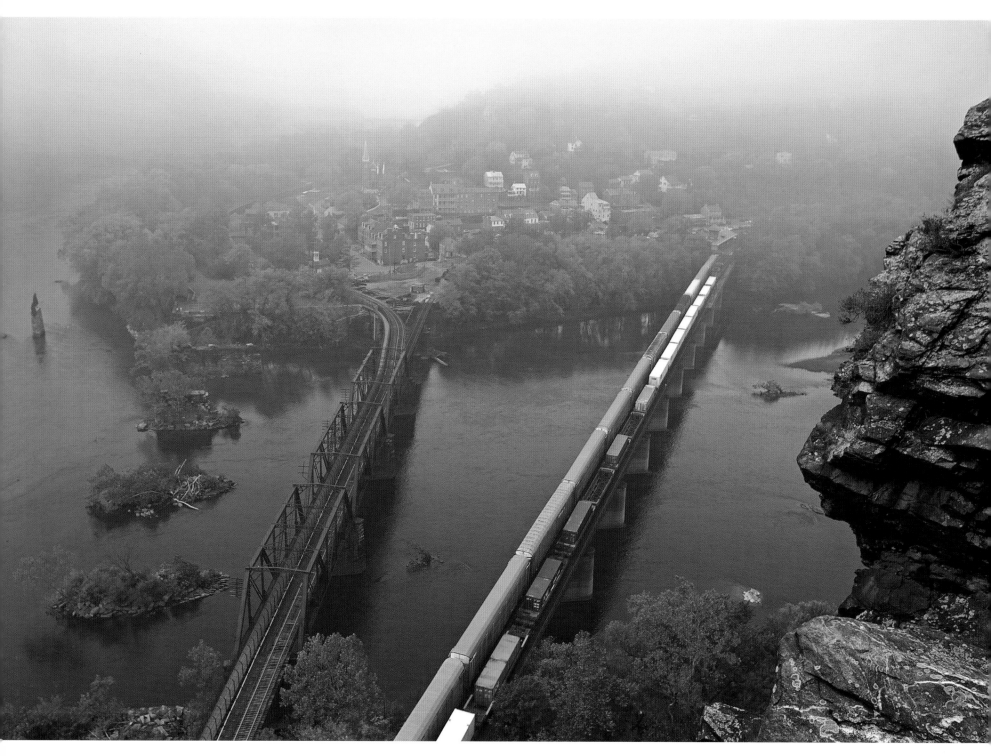

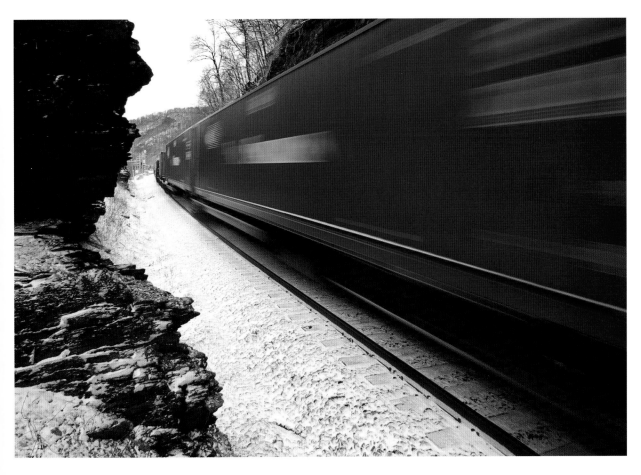

The rails passing through Harpers Ferry are busy all year long. On one of the dual bridges over the Potomac River, CSX freight trains pass each other on a foggy autumn morning (opposite). Blue freight cars streak through a gap in the rocks just outside of town on a winter day (above). A warm summer day finds an angler wetting his line in the shadow of the railroad trestles as a train crosses over head (right). The transport of freight by rail continues to grow. CSX Transportation, which owns and operates the tracks that run through Harpers Ferry, was formed by the merger of the old Baltimore and Ohio Railroad, one of the nation's first, with other railway systems in the 1980's. Before the Civil War, the B&O was a fast growing company with over 200 locomotives, more than 100 passenger cars, and well over three thousand freight cars. Aside from a legal dispute with the C&O Canal over right of way, nothing slowed the progress of the B&O. Then war broke out. At the start, the B&O tried to remain neutral but inevitably was dragged into the conflict, eventually siding with the Union. Before leaving Harpers Ferry in 1861, Stonewall Jackson commandeered locomotives and rail cars and sent them south. He destroyed many others. Over the course of the war, the B&O lost many miles of track and telegraph line, dozens of bridges and depots, and countless cars and engines.

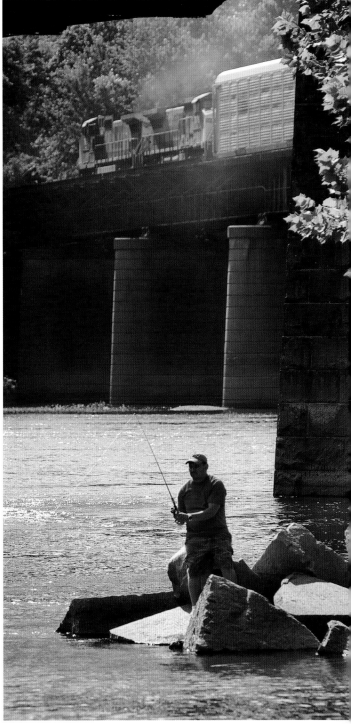

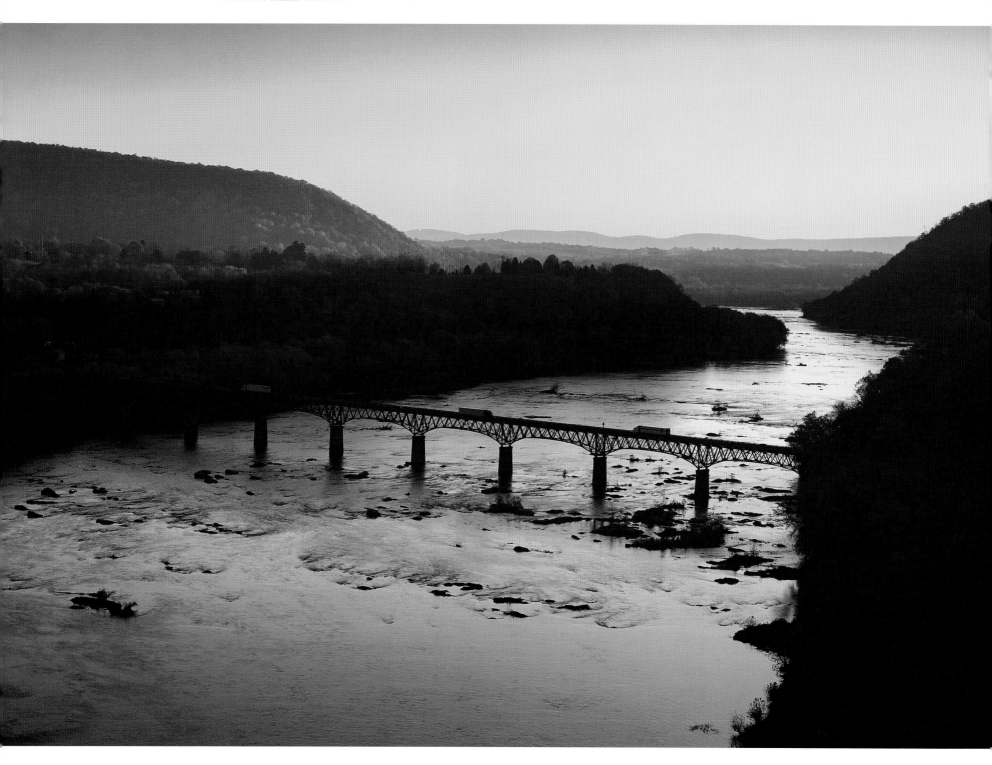

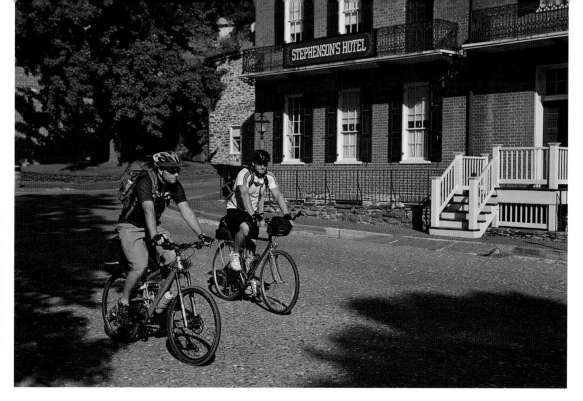

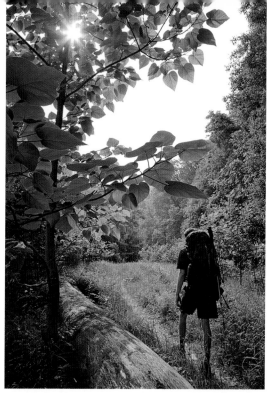

The canal boats, wagons, and stage coaches that once passed this way eventually gave way to trucks and buses, just as bridges of the 1800's replaced the ferry service of the 1700's. 18-wheelers haul goods across the Route 340 bridge spanning the Potomac (opposite). A shuttle bus ferrying tourists to and from the town passes by the old Shenandoah Canal (right), once used by gundalows. Long, narrow flat-bottom barges, these boats hauled iron, lumber, and other freight down the Shenandoah River, using the canal to skirt the river rapids. Today, cyclists (above) are more common around town than riders on horseback. Walking is still in vogue, however. A hiker treks the Appalachian Trail (upper right), which runs through the historic town.

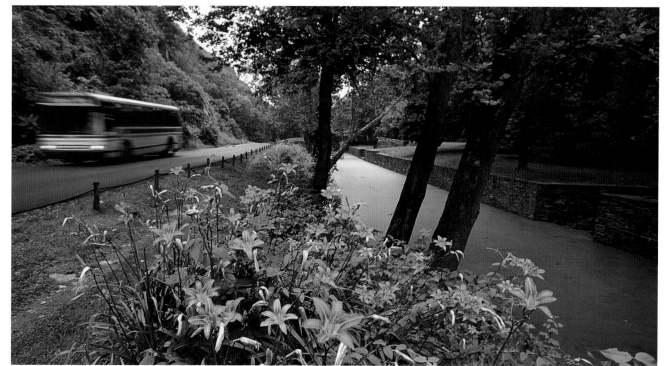

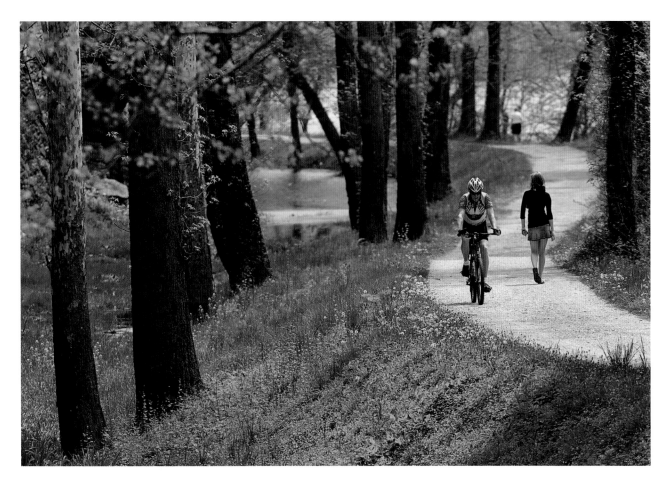

Across the Potomac River from Harpers Ferry lies the Chesapeake and Ohio Canal. From its eastern terminus in Washington, D.C., the C&O winds its way through the Maryland countryside for 185 miles, hugging the Potomac all the way to Cumberland. The canal once transported coal, grain, and lumber to Washington on mule drawn barges. When construction began in 1828, the canal held great promise for opening the west to economic expansion. But the project was plagued with financial problems from the start, and the "old ditch" never realized any great measure of success. The canal continued to operate into the 20th century, finally closing in 1924 after a devastating flood. In the end, it could not compete against the more progressive railroad. When plans were being drawn up to pave over the canal in the 1950's, Supreme Court Justice William O. Douglas, who opposed the idea, challenged editors of the Washington Post and others to walk with him the entire length of the towpath. Douglas was certain that he who did "would return a new man and...help keep this sanctuary untouched." His challenge was accepted. The eight day walk and the press coverage it received turned the tide against the planned parkway. In 1971, the C&O was dedicated a National Historical Park. Today, a three mile stretch of the towpath (right) from Harpers Ferry to Weverton is part of the Appalachian Trail.

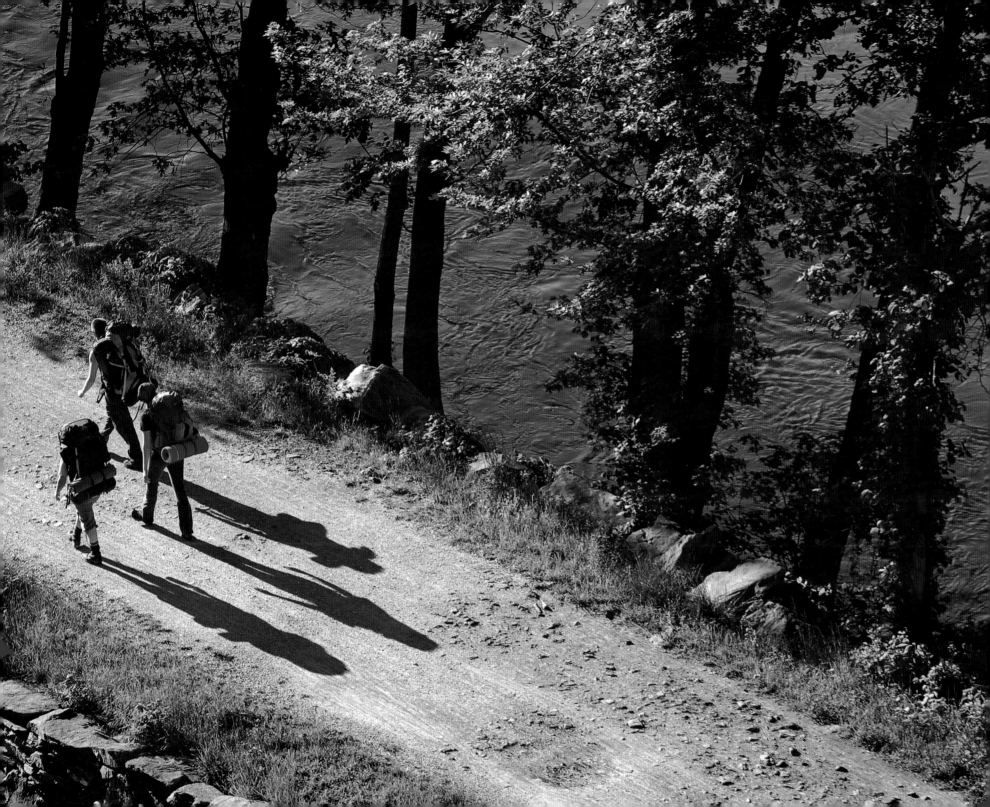

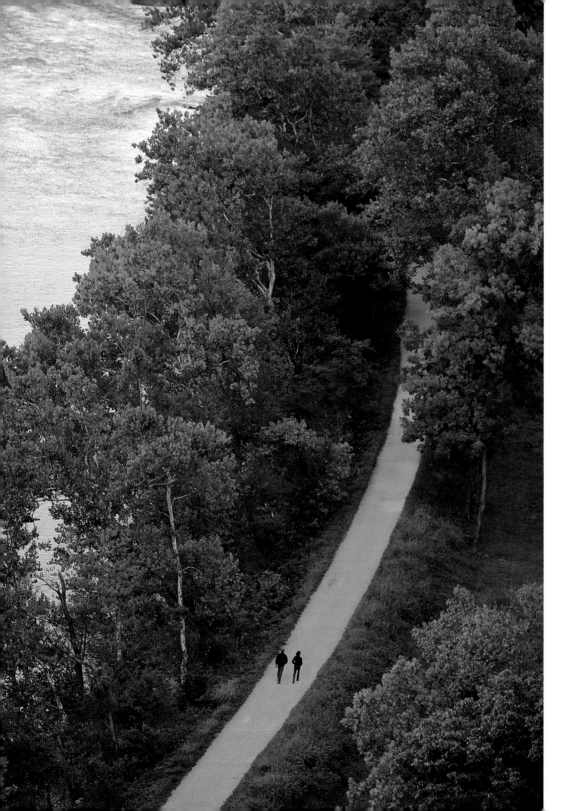

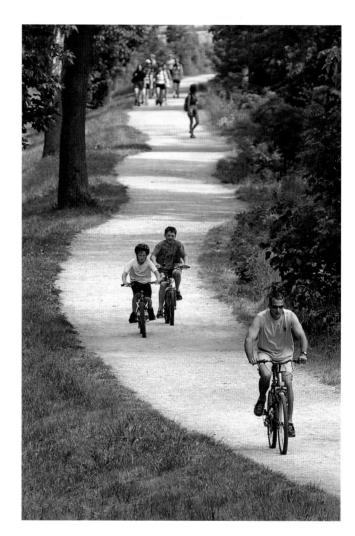

Today the C&O Canal towpath is a popular hiking and biking trail. At times, traffic on the path can become quite heavy, especially on a pleasant summer weekend. But generally the beige ribbon along the Potomac is a quiet place to walk or ride. And the breezy views of the Potomac are always a treat. The canal holds little water these days, at least where it passes by the Ferry. Closer to Washington, many miles of the canal are navigable by canoe. Here, the old waterway is more a long, damp depression in the earth, filling with wildflowers in the spring. Pools do form after heavy spring rains, but they are short-lived.

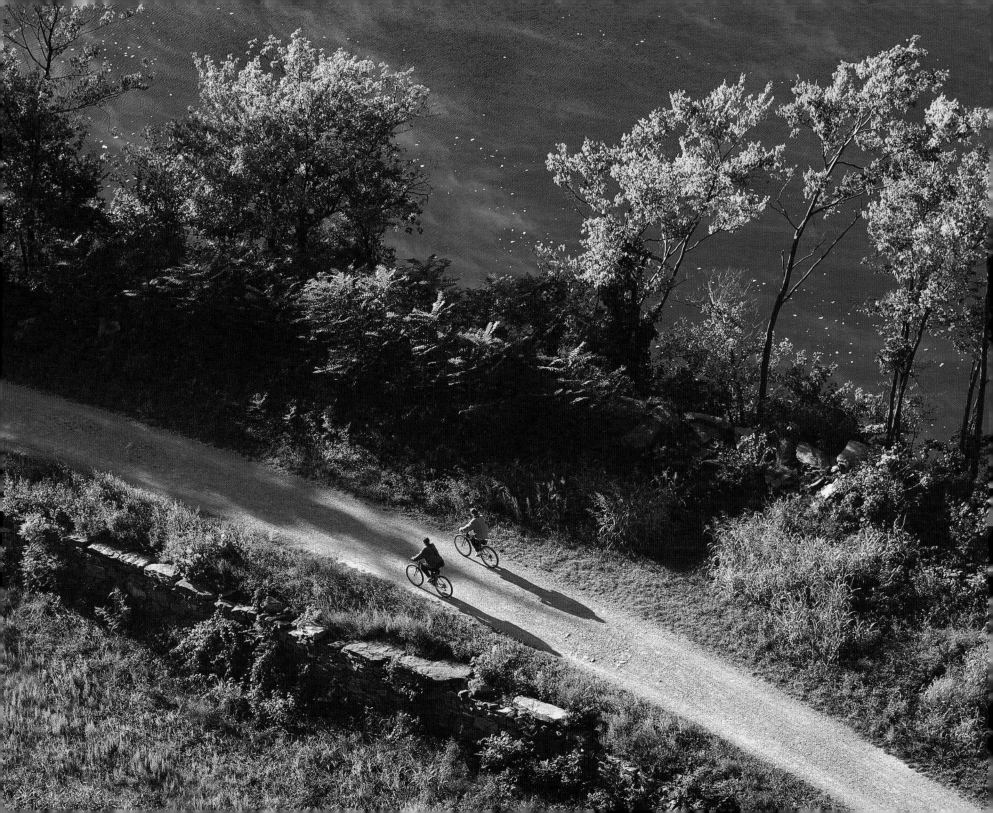

In the spring, clusters of bright pink flowers crowd the dark branches of Eastern Redbuds growing by the old canal. The small flowering trees attract carpenter bees and, for the visitor, they offer a dazzling accent to the tender green forest that flourishes here. These showy flowers, together with a host of others that appear in the spring, inspire wildflower walks and bike rides along the towpath. Such leisurely pursuits are a far cry from the original use of the C&O. In the 1870's, as many as 800 barges–pulled by over 2000 mules–plied the waters of the canal, the average boat making 25 round trips a year. This was the C&O's heyday. It was not uncommon for a canal boat captain to have his family on board for the trip. They would share a single 12 by 12 foot cabin. Each barge required two sets of two mules, each pair working six hour shifts. The resting mules were stabled in the front of the barge, along with their supply of hay. The 185 mile trip from Cumberland to Georgetown was long and demanding, the family working eighteen hour days for a week straight. Coal was the principal cargo, although barges transported grain and lumber as well. A boat could carry 100 tons of coal per trip, earning the captain twenty five dollars. During the Civil War, Union forces used the canal to transport troops and war supplies, and both sides used the towpath as a road. Barge mules were often confiscated for the war effort.

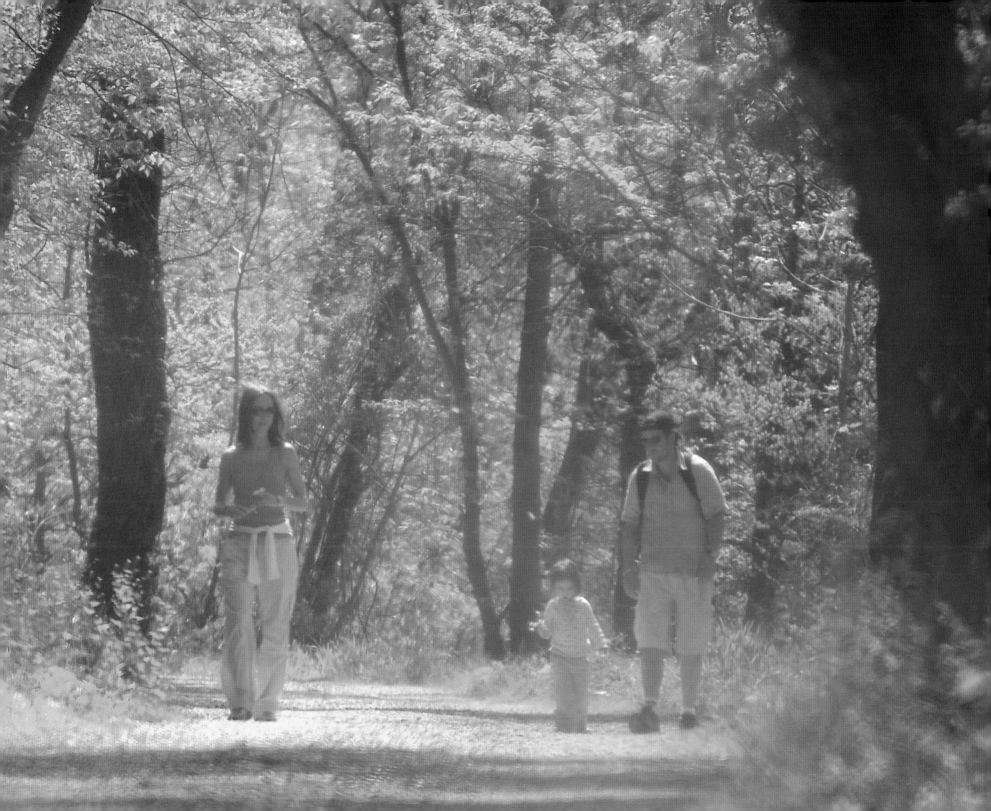

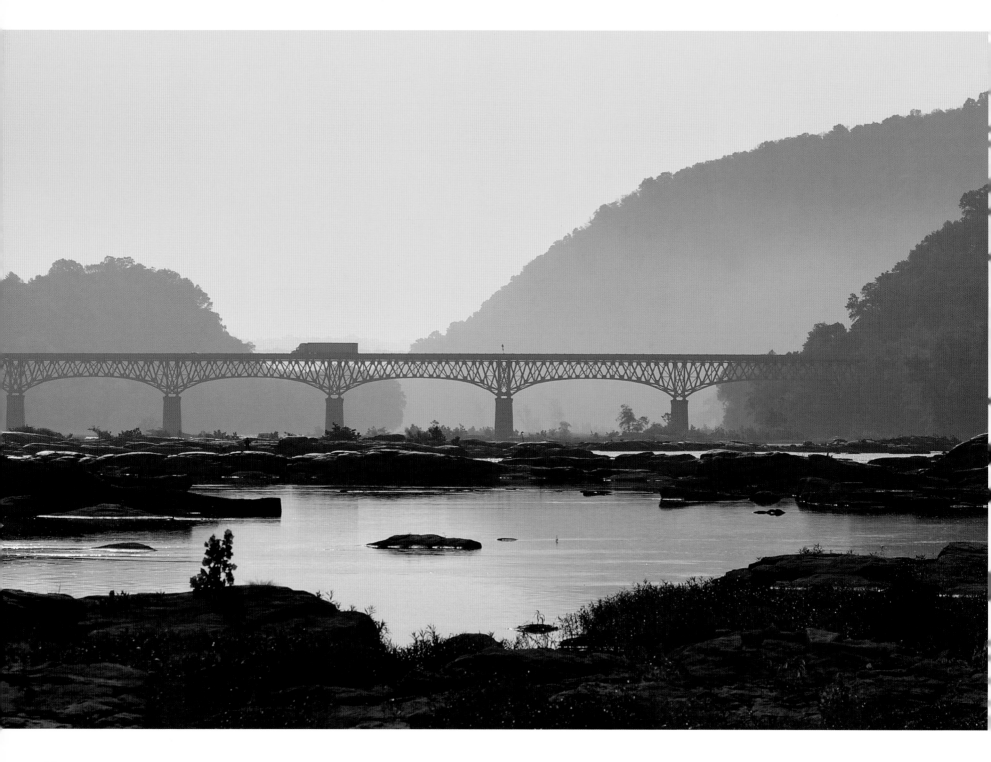

Today, roadways are the principal transportation lines to Harpers Ferry, and the main artery passing through the area is U.S. Route 340. Running west out of Maryland's Frederick Valley, the highway carries vehicles over the Potomac River into Virginia (opposite). This view looking east shows how dramatically river levels can drop in the summertime. Within a mile of crossing the Potomac, Route 340 passes into West Virginia (right) before traversing the Shenandoah River (below). Under the north side of the bridge is a popular spot for launching small boats. From here, Route 340 heads to Charles Town, the seat of Jefferson County. During the Civil War, the road was used by armies moving in and out of the Shenandoah Valley. Six miles west of the Ferry, Charles Town was founded by George Washington's younger brother Charles in the 1780's. Its courthouse was the setting for the 1859 trial of abolitionist John Brown.

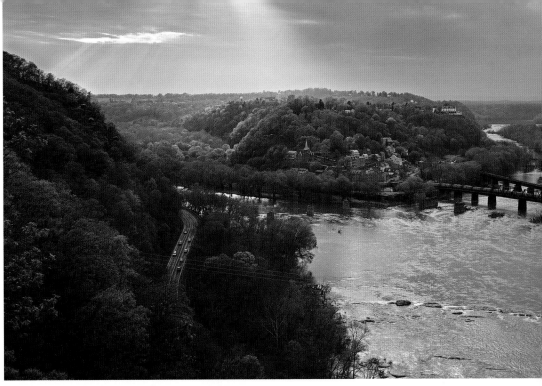

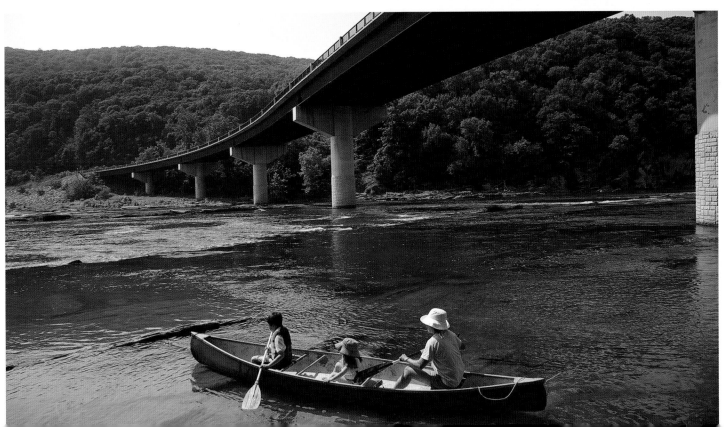

89

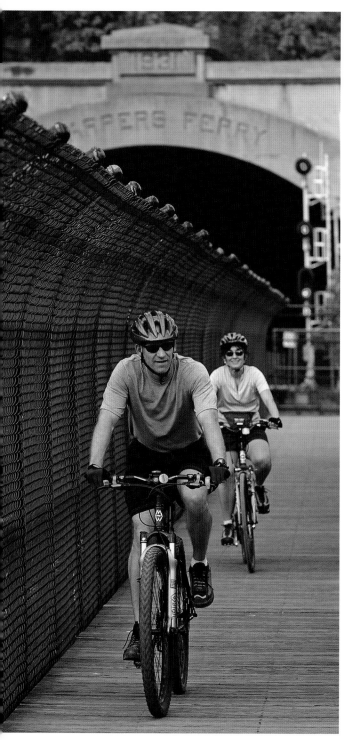

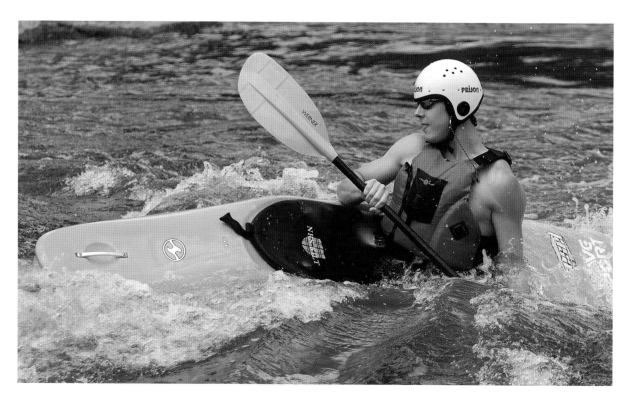

Harpers Ferry is a crossroads in space and time. Offering a striking contrast to 21st century visitors, volunteer reenactors portraying Union cavalry soldiers ride down Shenandoah Street one autumn day (opposite). Today, visitors often employ lightweight hiking gear while trekking the local trails, such as this AT hiker (right). Or they may ride alloy bicycles into town, like this couple crossing the Potomac after an outing on the C&O Canal towpath (left). On the river, polymer kayaks propelled by carbon fiber paddles are the order of the day (above).

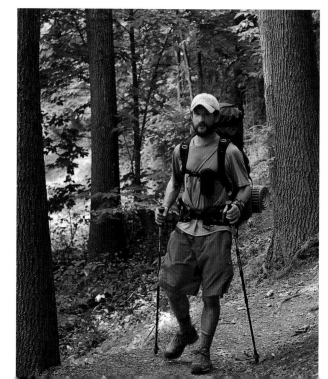

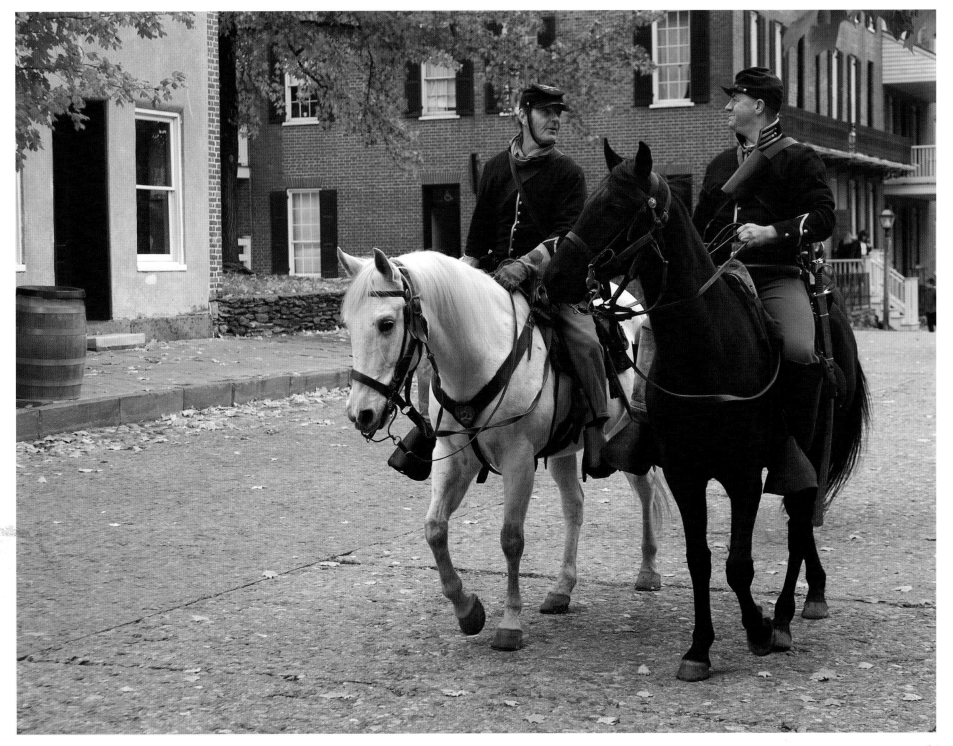

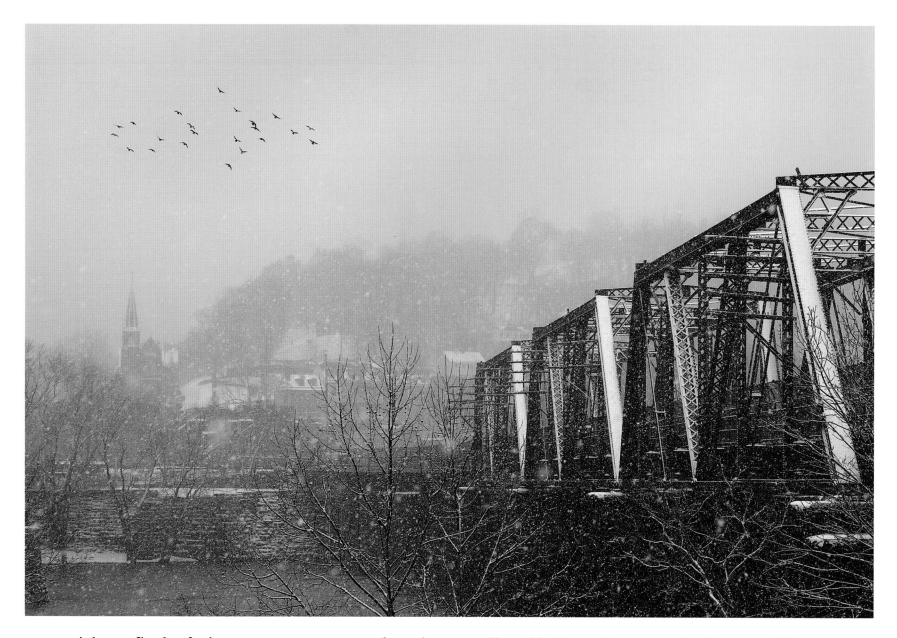

A large flock of pigeons roost year-round on the two railroad bridges that cross the Potomac River.
A pedestrian walkway runs along one of the bridges, allowing visitors easy access to the C&O Canal and the hiking trails on Maryland Heights. People walking across the bridge normally will not flush the birds. But a rumbling freight train, with the engine's whistle trumpeting its arrival, is certain to rout the pigeons, sending them circling about in a frenzy.

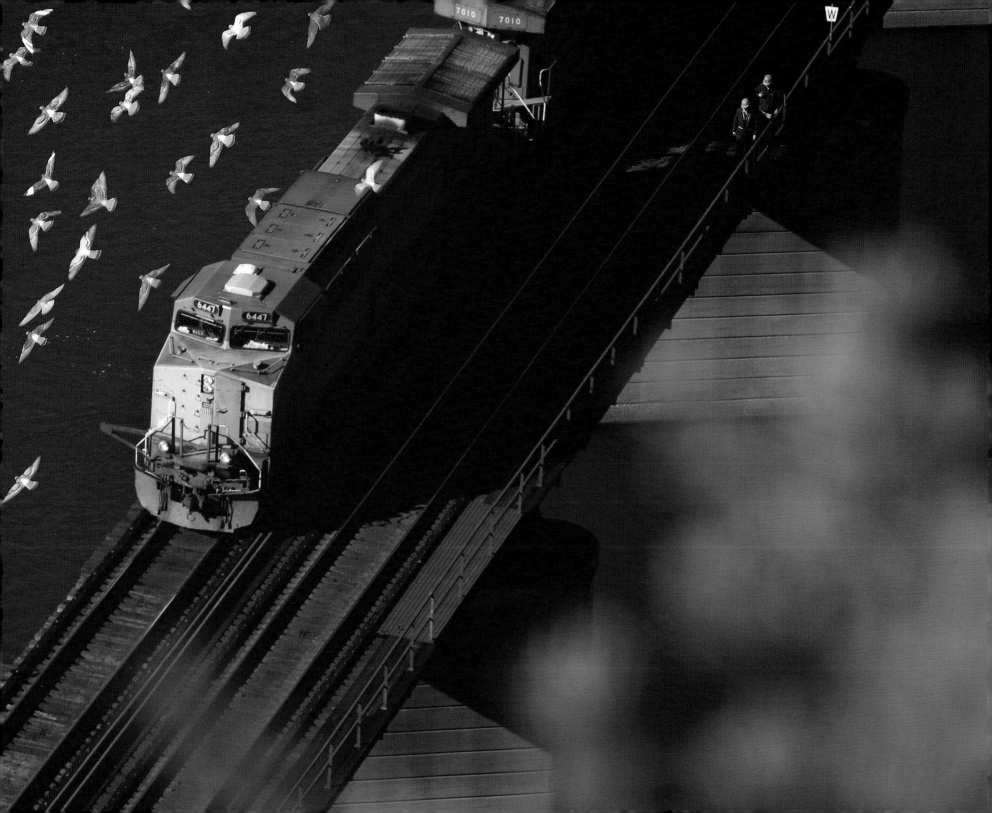

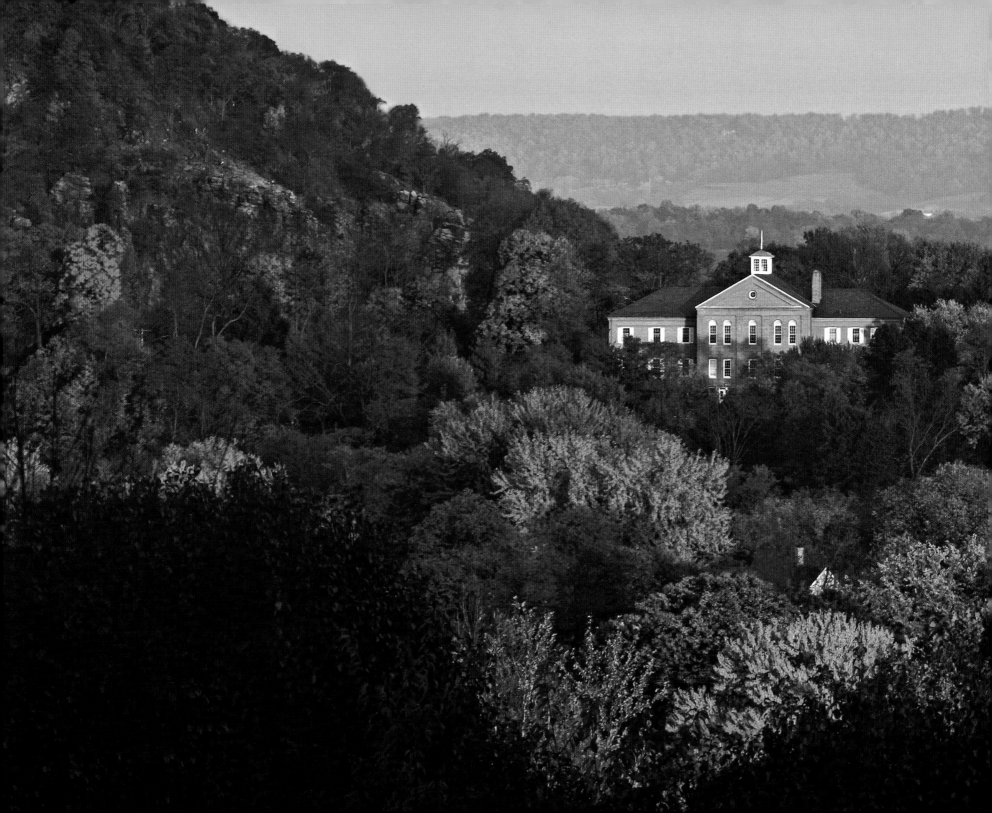

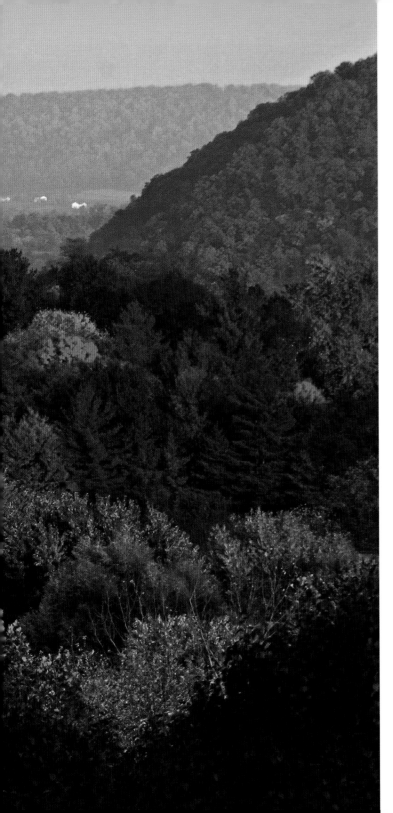

5

John Brown's Legacy

Like the mythical phoenix, Storer College rose up from the devastation wrought by the Civil War. With much of the town in ruin and the Armory and Arsenal destroyed, a few federal buildings on Camp Hill remained largely intact. By 1867, they were home to one of this nation's first black schools. The long and bloody war that John Brown had prophesied may have freed the slaves, but not from the chains of ignorance and poverty. Beginning as a one-room grammar school for freedmen, Storer became a full-fledged teachers college. In 1881, on the school's fourteenth anniversary, Frederick Douglass, a trustee of the college, delivered a memorable speech on the legacy of John Brown. "Did John Brown fail?" he asked. "Ask Henry A. Wise in whose house less than two years after [the war], a school for the emancipated slaves was taught." A Confederate general during the war, Wise was governor of Virginia before the war and had signed Brown's death warrant. Douglass went on to say that "John Brown began the war that ended American slavery, and made this a free republic." In this new republic, former slaves and their descendants were free to pursue their dreams at Storer College, which remained open until the 1954 Desegregation Act became law. Ten years later, the Storer campus was dedicated the Stephen T. Mather Training Center, named for the first director of the National Park Service. Carrying on the tradition of education, the center is a national training facility for the Park Service.

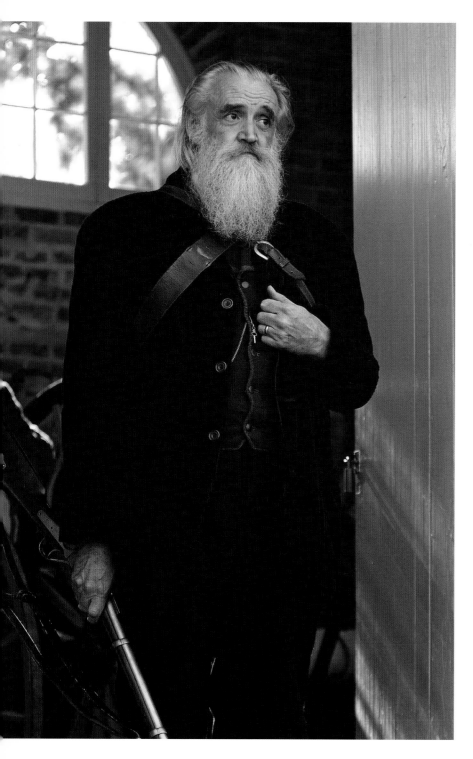

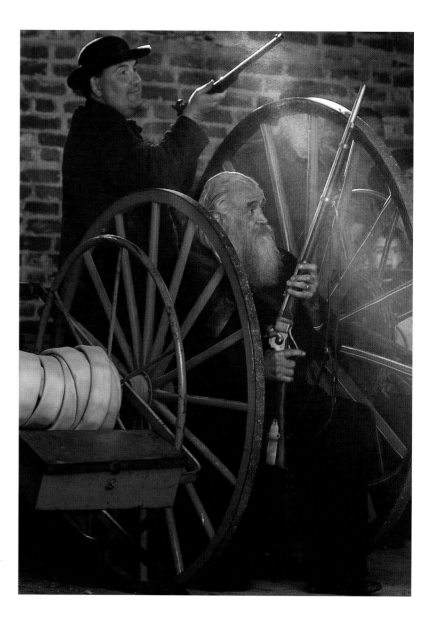

"I, John Brown, am now quite certain that the crimes of this guilty land will never be purged away, but with blood..." Reenactor Steve Hanson (left), portraying Brown, speaks to the justification of the abolitionist's raid on the Federal Arsenal at Harpers Ferry. Brown and his men planned to seize arms and lead an uprising of slaves.

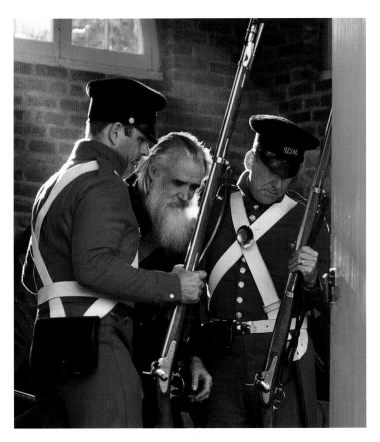

John Brown's raid took the lives of seven innocent townsmen, including the mayor, Fontaine Beckham. Brown lost many of his own men as well, including two of his sons. He was ultimately hanged for his actions. At the time, Brown's raid appeared heroic to many Americans, particularly northerners. Brown was praised by the likes of Emerson and Thoreau. But most southerners thought his raid an abolitionist plot, possibly advanced by the Republican Party, at the very least a threat to the institution of slavery. John Brown's raid is debated to this day. He has to be considered one of the most controversial figures in American history. President Lincoln said he was a "misguided fanatic." Frederick Douglass saw Brown as a martyr to the cause of freedom. But whether John Brown is viewed as hero or fanatic, his doomed raid was a flash point in American history whose repercussions propelled the nation toward civil war. At the end of that long and bloody conflict, costing the lives of over 600,000 Americans, the institution of slavery in this nation was abolished for good.

Leading his small "army of liberation," Brown attacked the town on October 16, 1859, taking hostages and killing the train station's baggage master, Hayward Shepherd, a free black man. Townsmen and local militia fought back, cornering Brown and his remaining men in the fire engine house, remembered today as John Brown's fort (right). Casualties were inflicted on both sides, and Brown continued to hold hostages. U.S. Marines (above), under the temporary command of Army Colonel Robert E. Lee, soon arrived by train from Washington and captured Brown and his surviving men. Before the year was out, Brown was tried and executed for treason against the Commonwealth of Virginia.

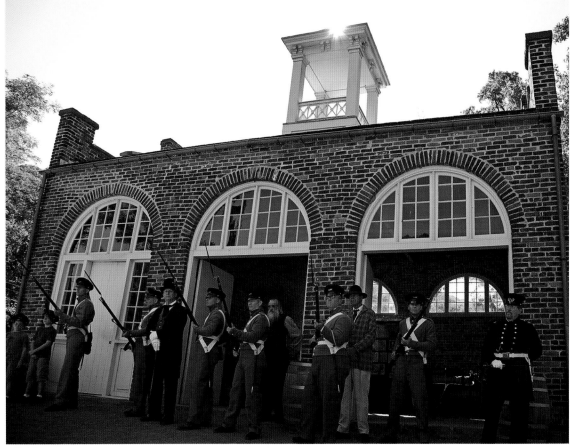

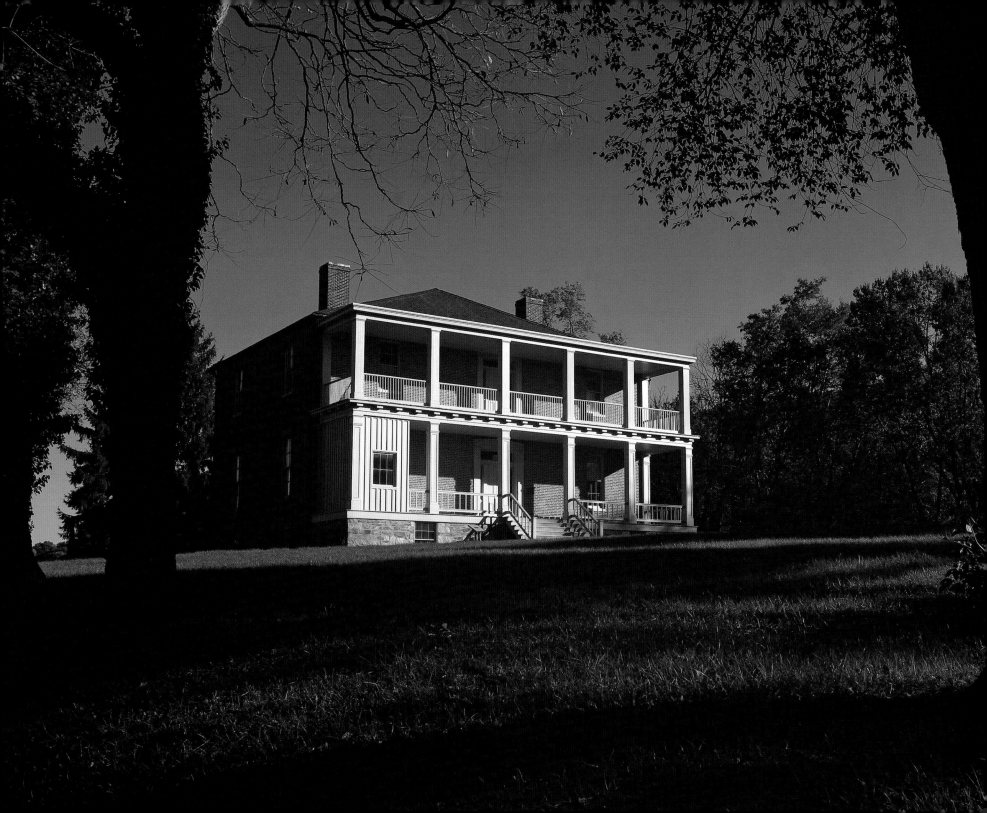

The Lockwood House was the birthplace of Storer College. After the war, the Freewill Baptist Home Mission, led by Reverends Nathan Brackett and Silas Curtis, established a grammar school for freed slaves in this former paymaster quarters. The house was riddled with holes from cannon and musket balls, but missionary teachers put the place to good use. They educated their students not only in the three R's but also counseled them in the ways of everyday life. The first class had only 19 students, but enrollment grew to 75 within five months. Over 30,000 freed slaves lived in the upper Shenandoah Valley, including Harpers Ferry. Looking to the future, Brackett soon realized that more teachers would be required to meet the educational needs of all the freedmen. His newborn grammar school would have to train teachers. With financial support from John Storer, a philanthropist from Maine, the school eventually became a degree-granting teachers college, receiving its state charter in 1868. In the beginning, Storer faced opposition from townspeople, some of whom were openly hostile to both teachers and students. Teachers were stoned on their way to school, and some of the older students took to carrying weapons for protection. Although Storer was primarily a black institution throughout its history, the school was open to students of all races and both genders.

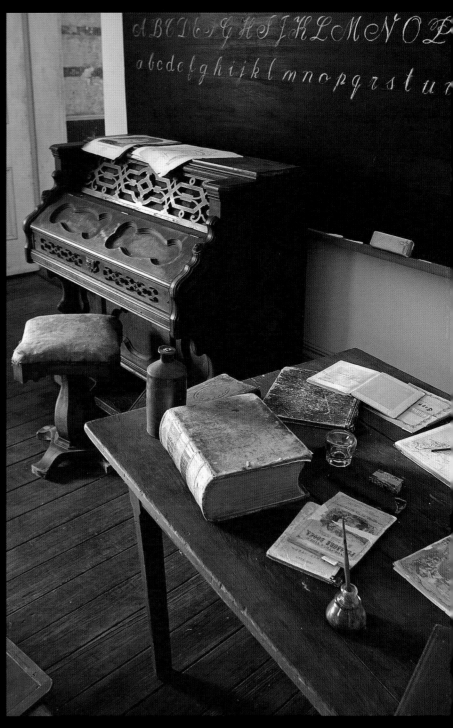

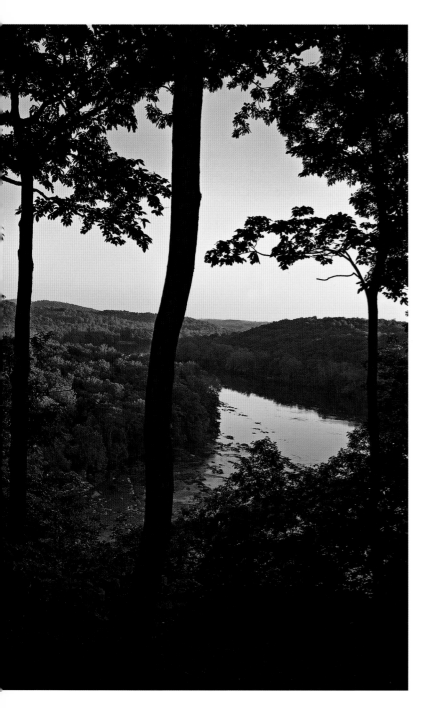

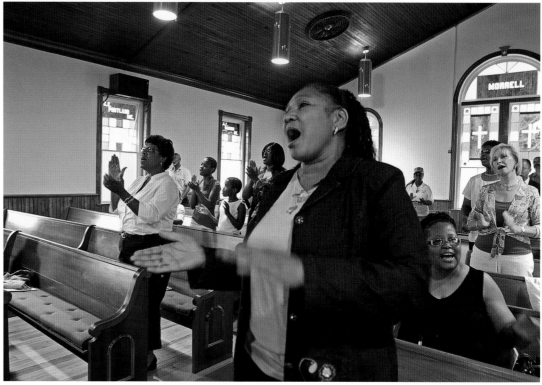

Close to thirty years passed before the Freewill Baptists of Harpers Ferry built their own church. In 1894, the Curtis Freewill Baptist Church was completed, named in recognition of Silas P. Curtis, who played a significant role in the founding and development of Storer College. Worship services were held in the church until 1955. Today the old church is part of the National Historic Park. With the restoration of its interior complete, the church is now open on special occasions. A recent service (above) followed the commemoration of the historic barefoot pilgrimage by members of the Niagara Movement to John Brown's fort in 1906. At the time, the fort was located on the Murphy Farm (left), which overlooks the Shenandoah River just south of Harpers Ferry. Originally a fire engine house, John Brown's fort has been moved four times in its interesting history. The pilgrimage of the early civil rights leaders to the fort was in honor and remembrance of John Brown's sacrifice. Today the Murphy Farm is part of the national park.

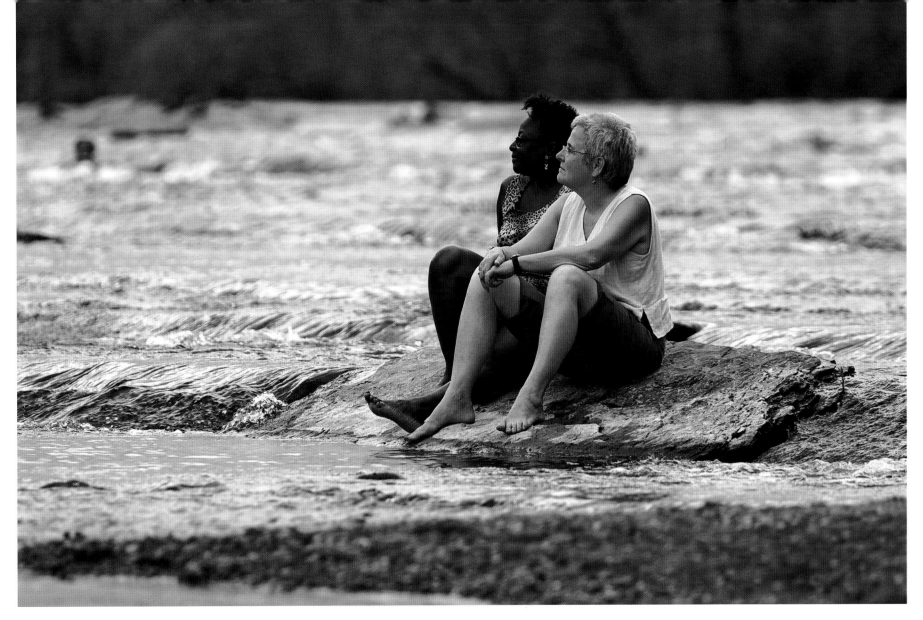

The history of black Americans in Harpers Ferry is a long and turbulent one. Before the Civil War, about half the black population was free while the rest were held as slaves. After the war, although black people were emancipated, they remained segregated. Jim Crow laws dashed any hopes of equality. In an effort to fight these injustices, Dr. W.E.B. Du Bois and other leading black Americans founded the Niagara Movement, a forerunner of the NAACP. The group held its second conference at Harpers Ferry in 1906. Still, advances were slow in coming. Close to fifty years would pass before desegregation laws were passed. Today, however, the town is a very different place. Two friends sharing a peaceful moment along the Shenandoah River reflect the change in racial attitudes over the last 150 years.

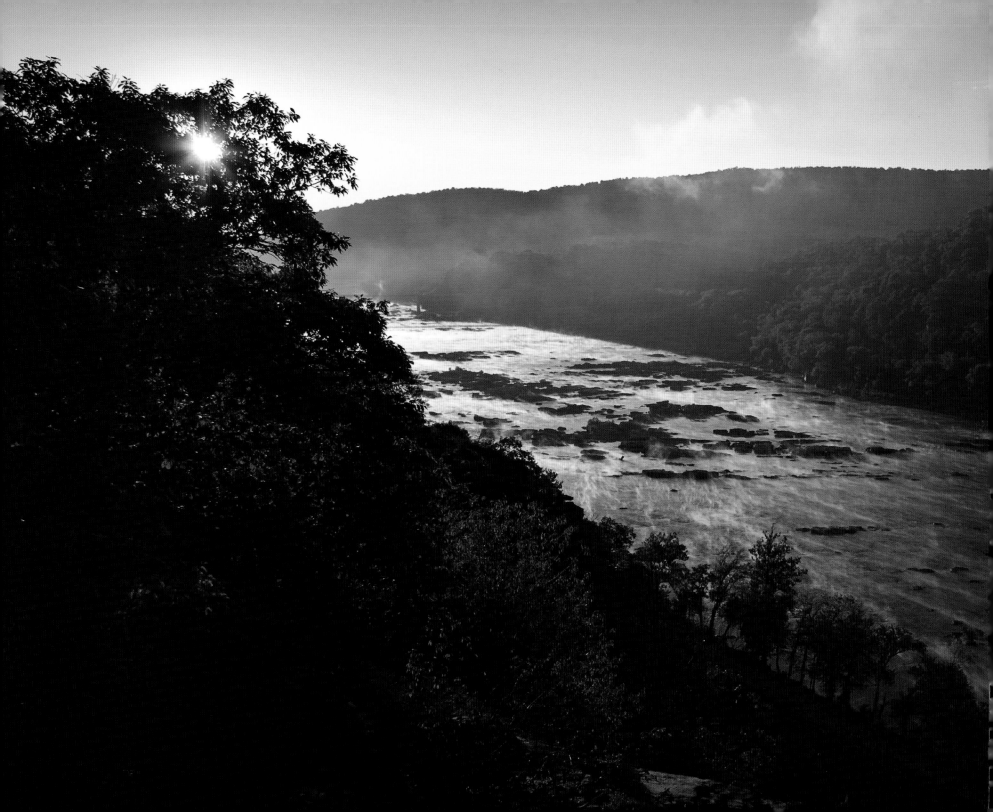

6

A Natural History

**"Harpers Ferry is a meeting place of winds and waters, rocks and range,"
wrote Carl Sandburg.** Here the Shenandoah River converges with the Potomac. Searching for a path to the sea, the two rivers slowly but inevitably carved a dramatic passage through the Blue Ridge Mountains. This gorge, once known simply as "The Hole," offered travelers easy passage westward. Over the years, the rivers coursing through here have been a sight to behold by anyone passing this way. Several rocky overlooks easily reached by hiking trails afford wonderful views of the two great rivers and the mountain ranges that tower above them. In his 18th century travel book, Notes on Virginia, Thomas Jefferson wrote that the gorge "is as placid and delightful as [it] is wild and tremendous." Moreover, he regarded the sight "one of the most stupendous scenes in Nature." On visiting the area 100 years later, one noted travel writer and geologist of the 19th century wrote, "Mr. Jefferson has spoken in somewhat extravagant terms." Perhaps, but what nature has to offer at this meeting place is certainly worth a look, whether you see it by river or by trail.

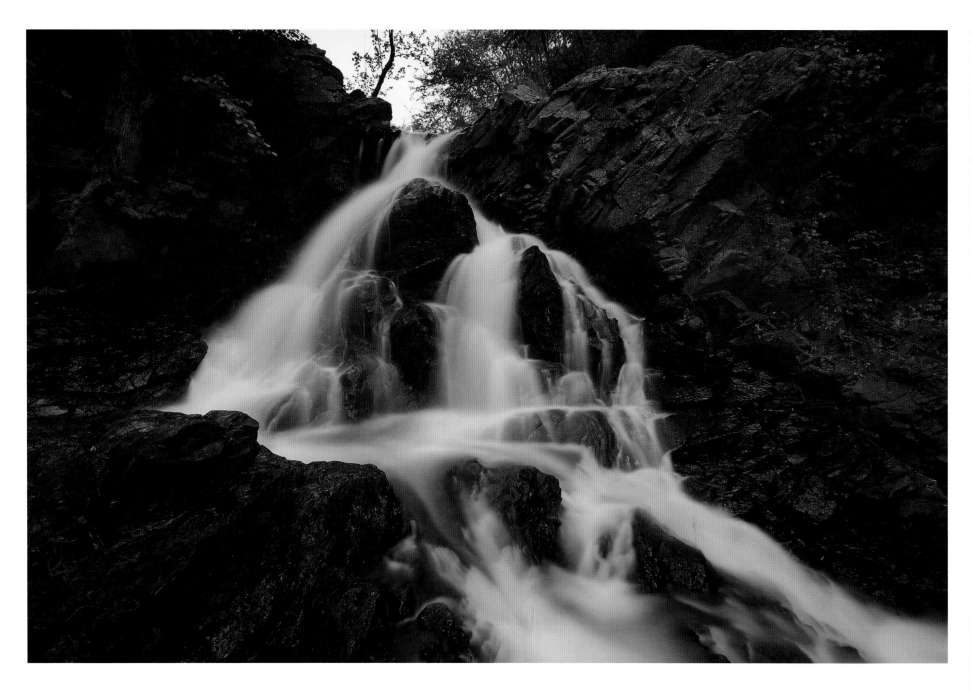

Many visitors to Harpers Ferry come for the history and stay for the views. The park offers stunning vistas from many rocky overlooks on the surrounding ridges (opposite). Also on view are jewels such as the Piney Run waterfall (above), which is a welcomed sight to weary paddlers after a long day on the river. Local outfitters end most of their river trips at Piney Run near the falls.

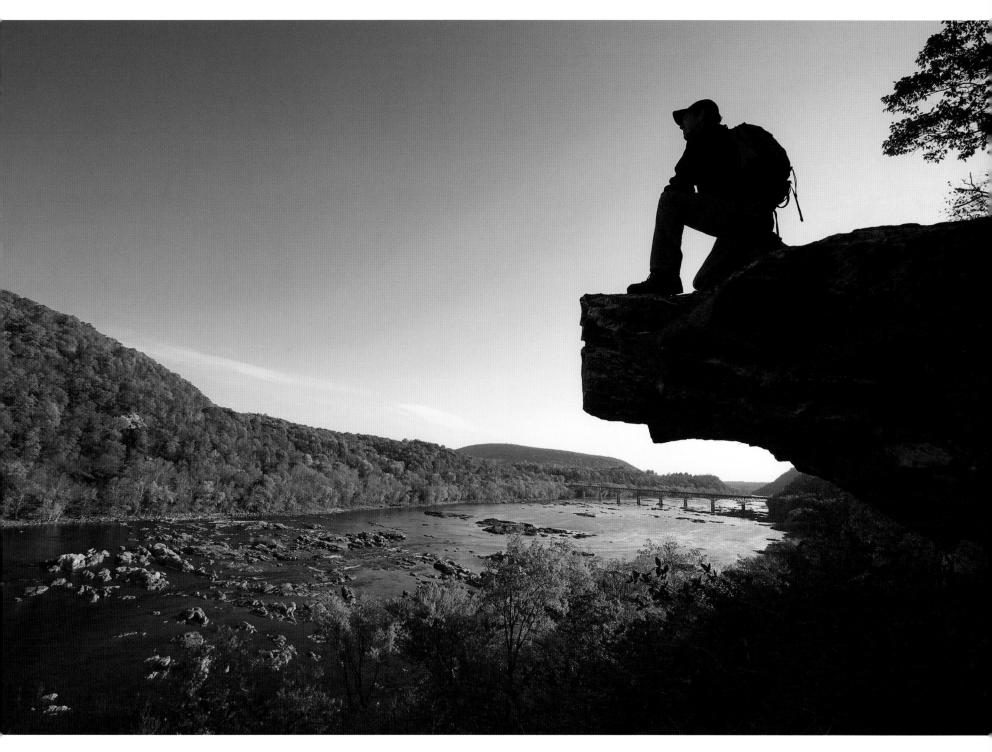

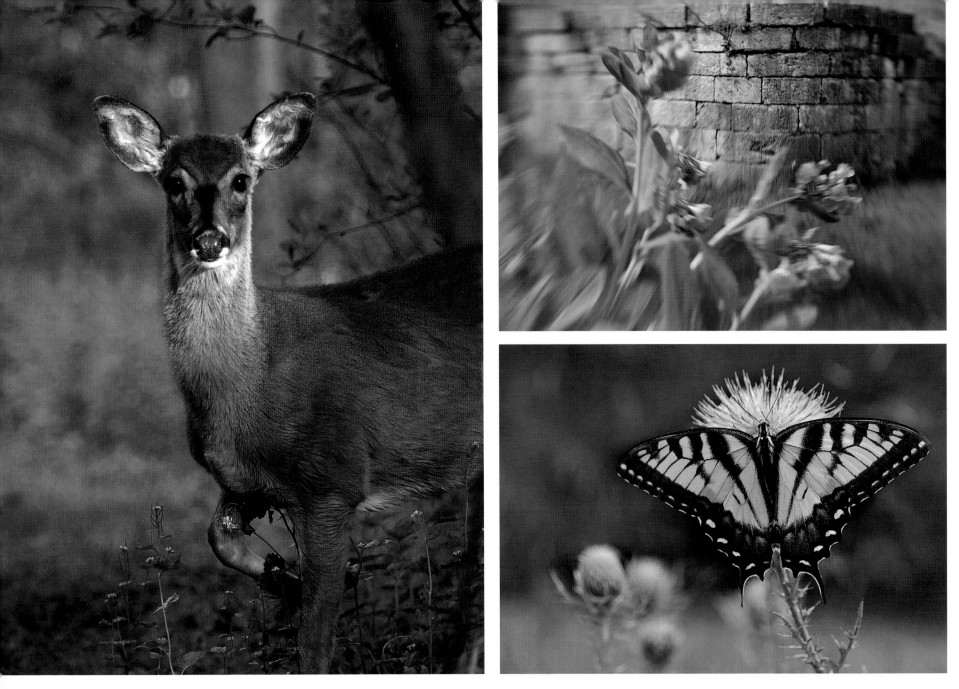

Springtime finds the return of Virginia Bluebells to Harpers Ferry. White-tailed deer look forward to the spring season, when food is more abundant. Eastern Tiger Swallowtails make an appearance, feeding on wildflowers such as Milk Thistle. Spring is also when Canada geese raise their broods of yellow-plumed goslings (opposite). A large number of Canada geese winter in the area.

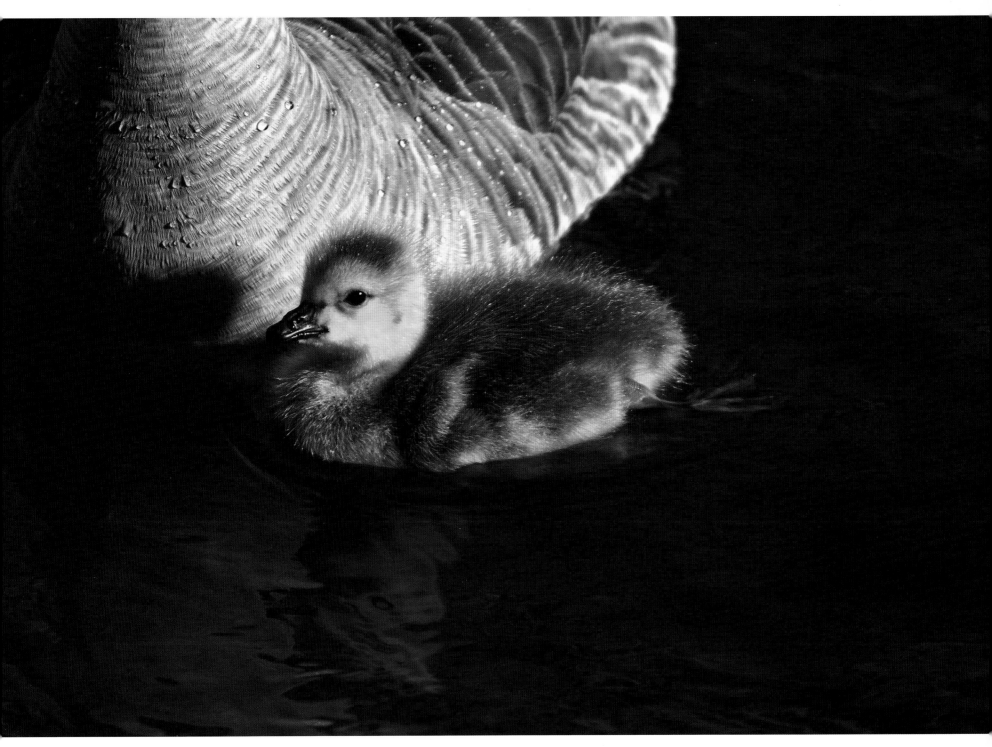

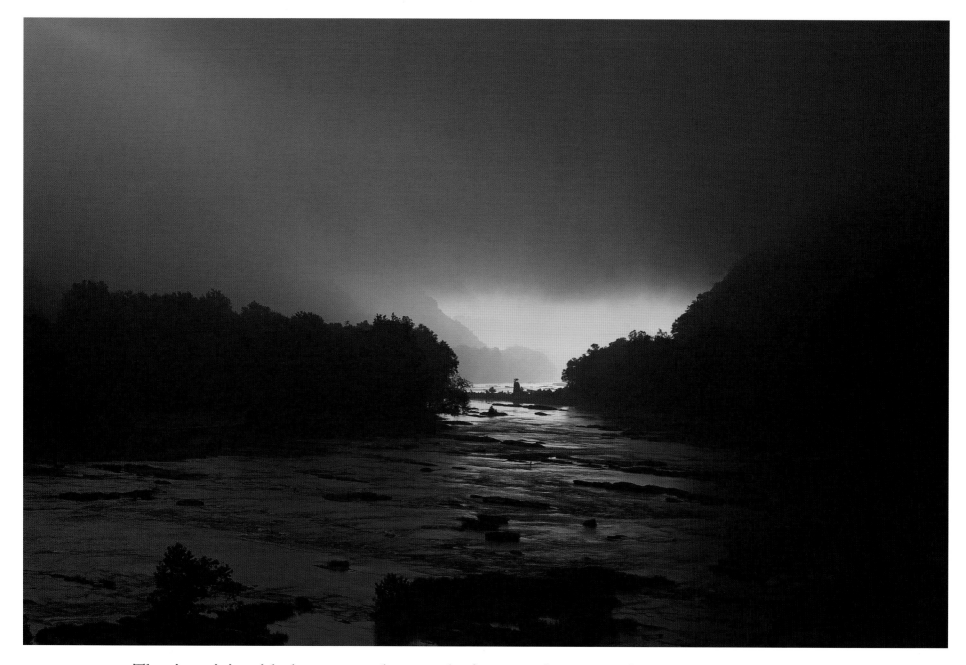

The rivers join with the topography to make for many foggy mornings at the Ferry, especially in the spring and fall. A heavy fog bounded by the high walls of the gorge settles in for many hours (above). On another morning, a light mist lifts off the Shenandoah at sunrise, quickly disappearing as the air warms (opposite).

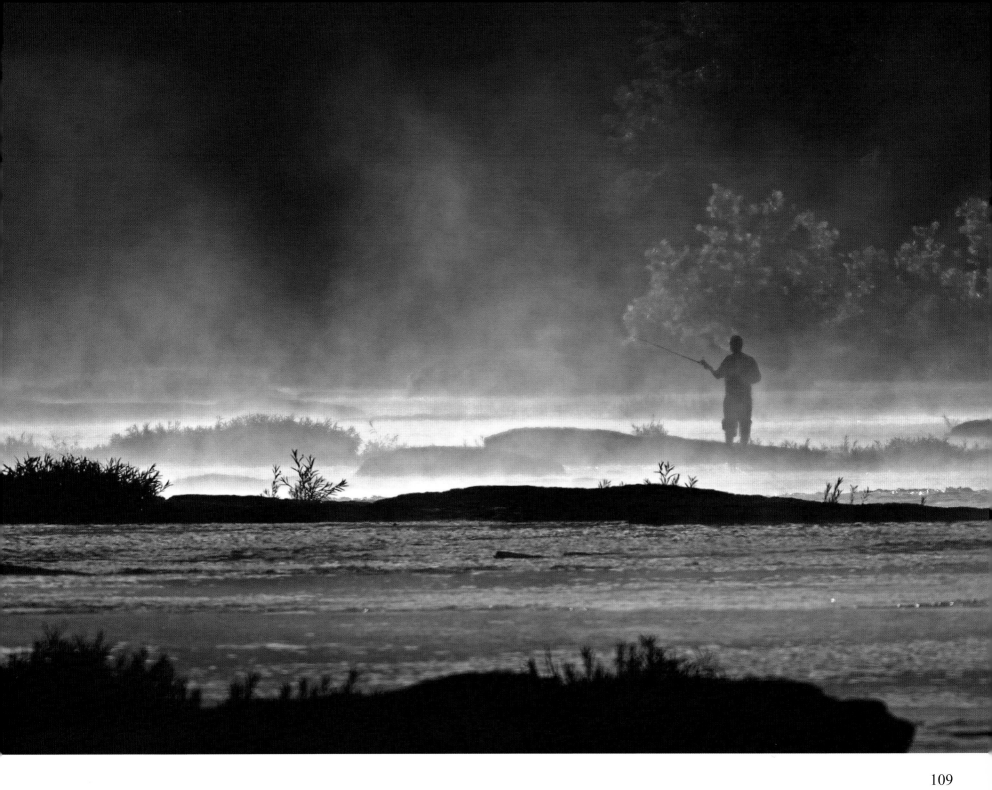

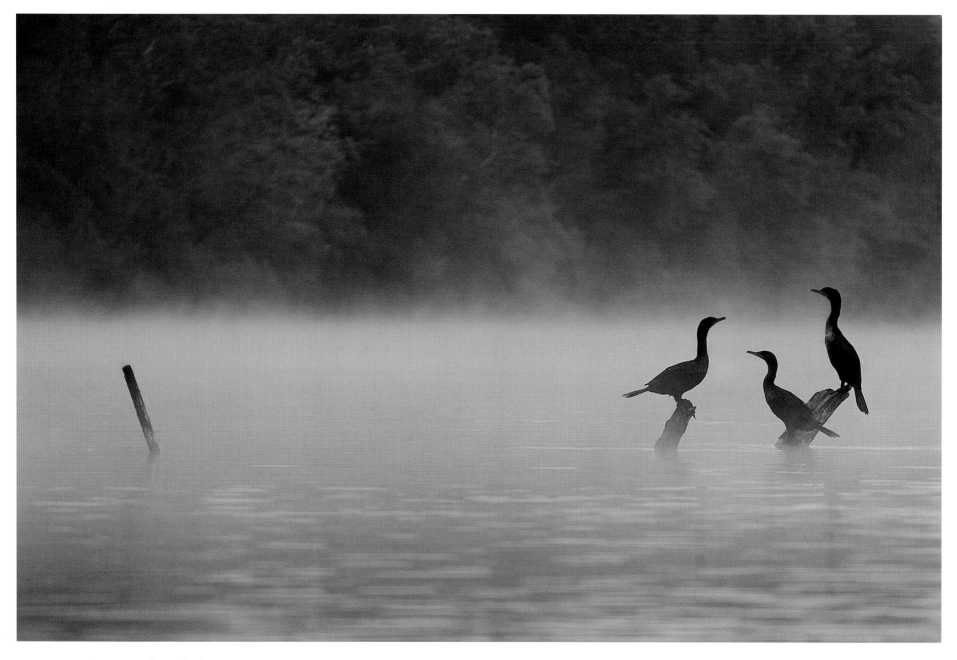

On a misty fall morning, cormorants perch on the truncated limbs of a tree submerged in the Potomac (above). From Maryland Heights, the C&O Canal towpath and Potomac River are just visible through a heavy October fog (opposite).

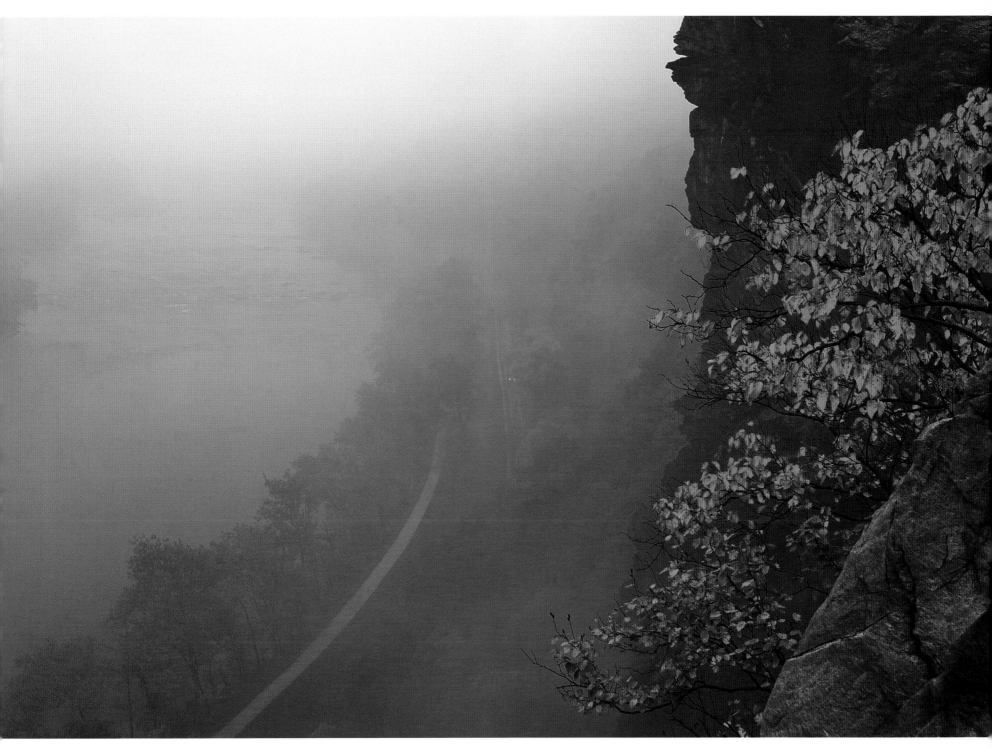

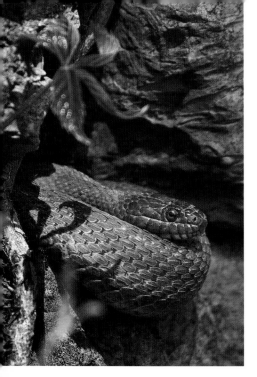

Nature is slowly reclaiming the ruins of Harpers Ferry.
Crumbling bridge piers on the Potomac are under siege (right). The crevice in a stone wall of the C&O Canal's Goodhearts Lock is home to a Northern Water Snake (left). The old Winchester & Potomac railroad line (below), which once supplied the bustling mill town on Virginius Island, now runs through woodlands. Today the trains that still travel this line share the tracks with White-tailed deer. A Great Blue Heron wades the Shenandoah Canal (opposite), originally built to allow boats to bypass the river rapids. Today, green algae blooms in the still waters of the old channel.

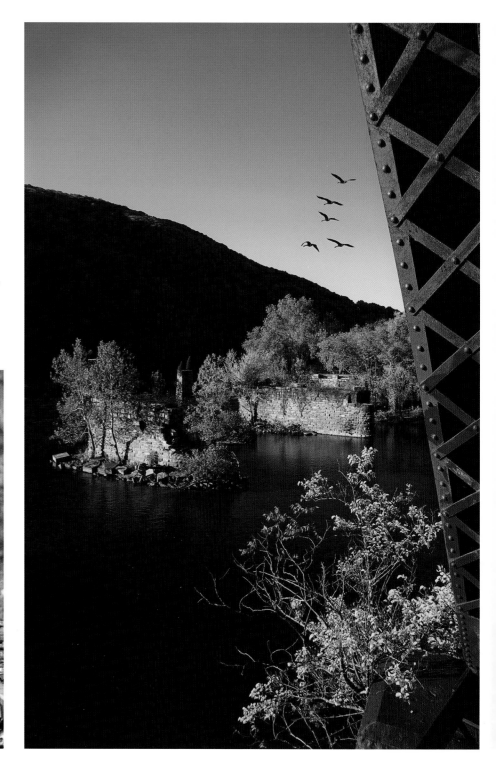

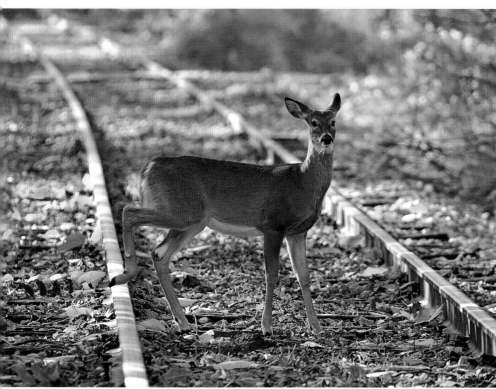

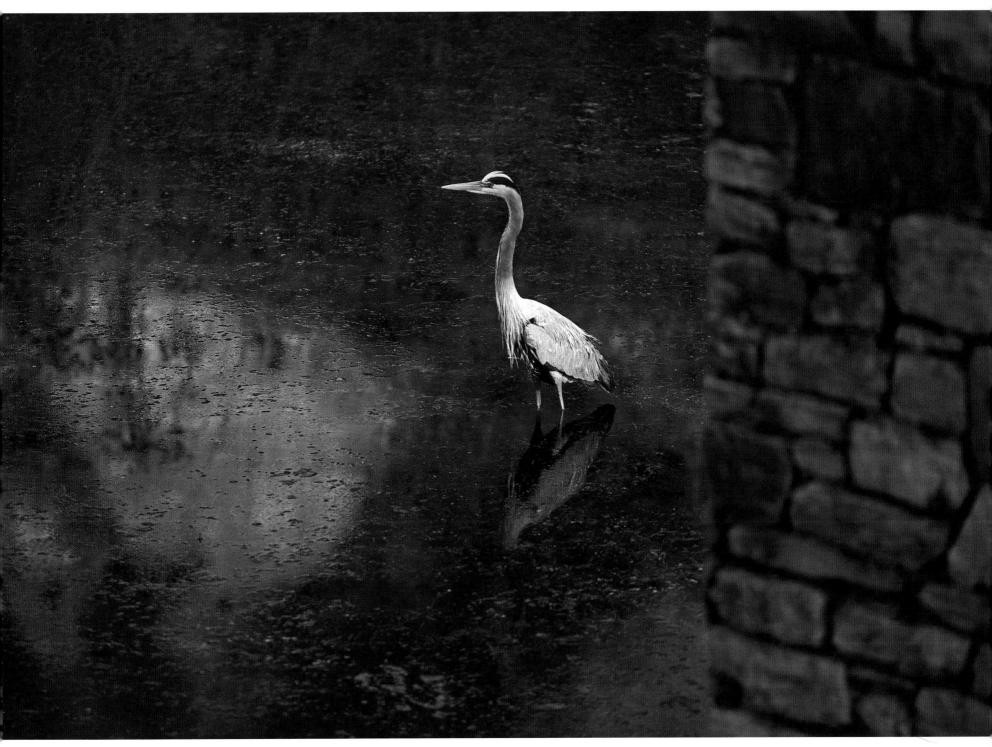

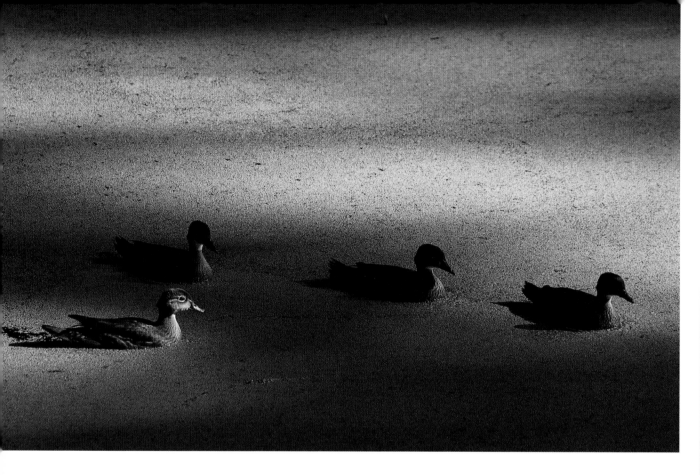

On the wing, on the water, or on the warpath, waterfowl abound here. Ducks, geese, and heron use the rivers as flyways (opposite). Canada geese are the most prevalent. A goose defends its nest atop an old bridge pier in the Shenandoah River (below). The algae choked Shenandoah Canal attracts Wood ducks, waterfowl that like it swampy (left). A mother and her young perch on a log, out of reach of the snapping turtles that lurk beneath (below, left).

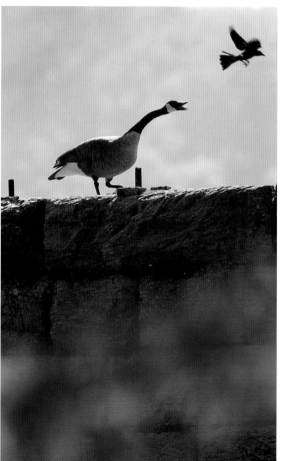

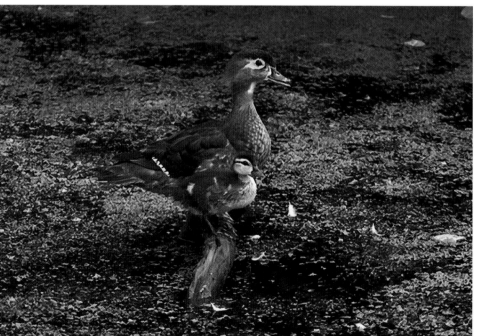

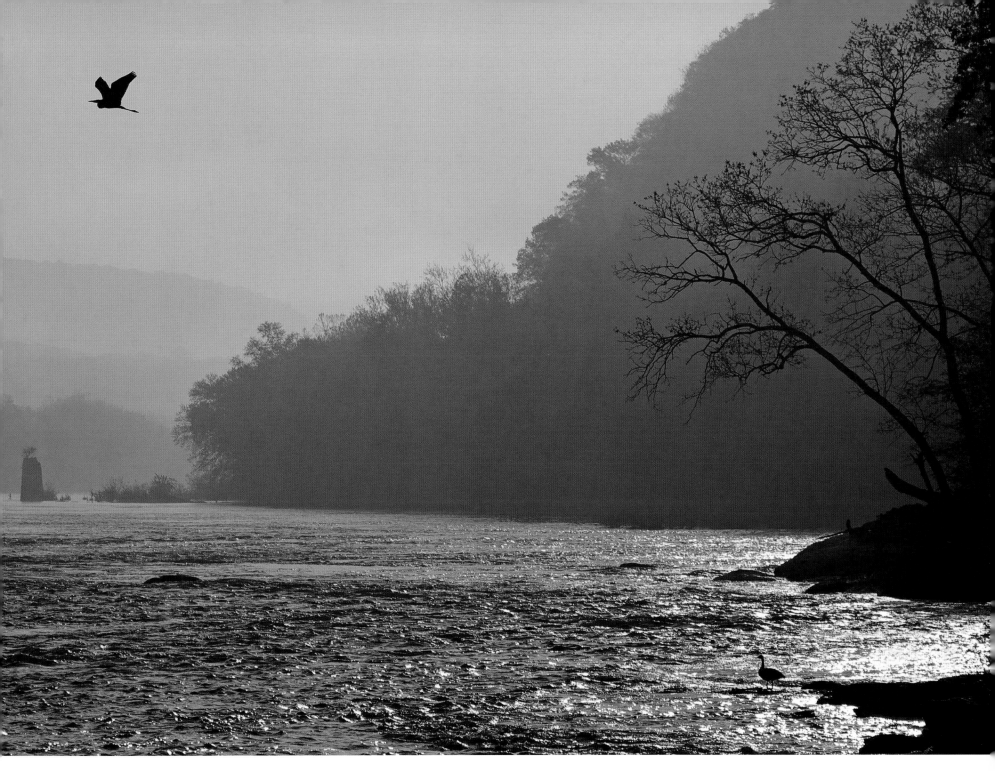

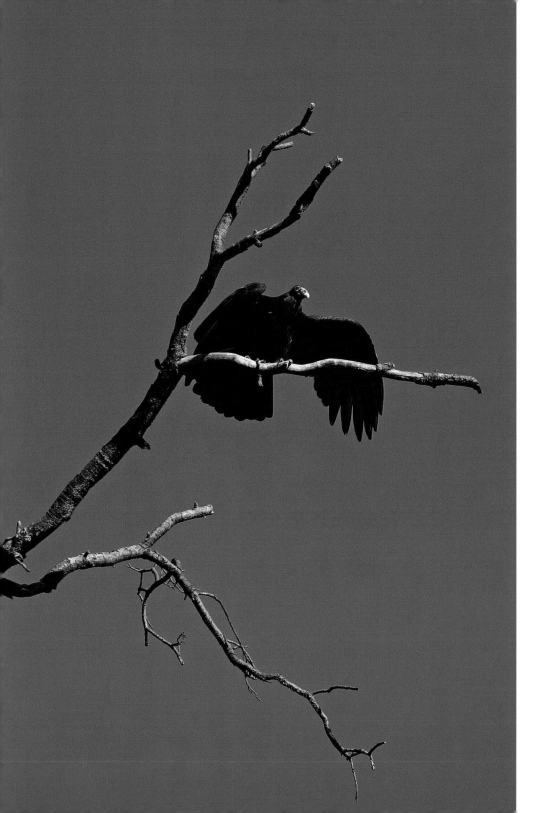

Vultures inhabit the mountain ranges surrounding the Ferry, both Black and Turkey. Elegant in flight, vultures soar the invisible thermals rising off the ridges, rarely flapping their long wings. These large birds–Turkey vultures can have wingspans of up to six feet– like to roost in dead trees. When resting, they often spread their long wings to dry their feathers and warm their bodies. Foraging by their highly developed sense of smell, vultures feed almost exclusively on carrion. Partly for this reason, these raptors are not held in high regard by many. Yet they do provide a valuable service, cleaning flesh from the bones of dead animals. Lacking a vocal organ, the vulture is limited to grunts and hisses, perhaps another reason some find these birds repulsive. The Turkey vulture's featherless, purplish red head and hooked beak certainly does not help its image.

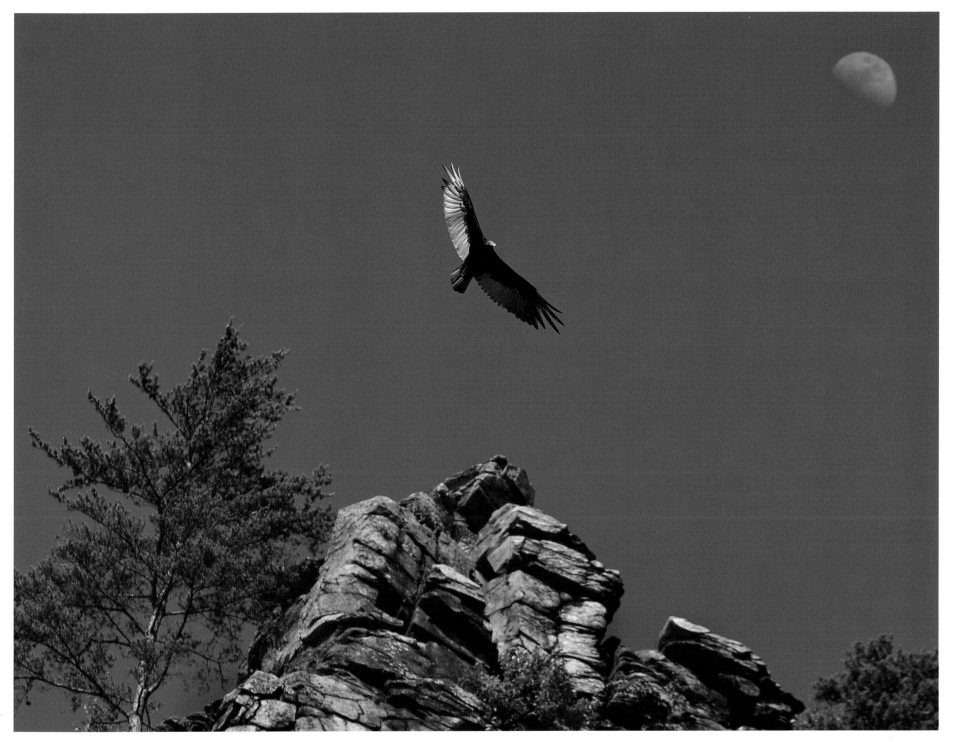

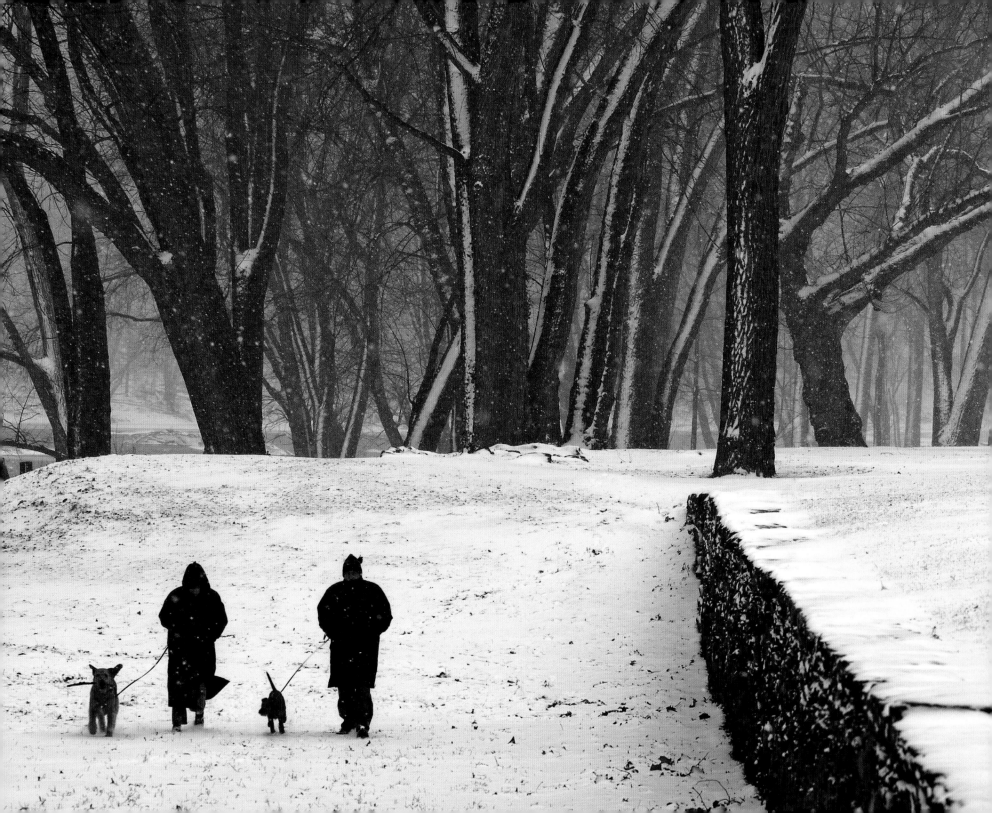

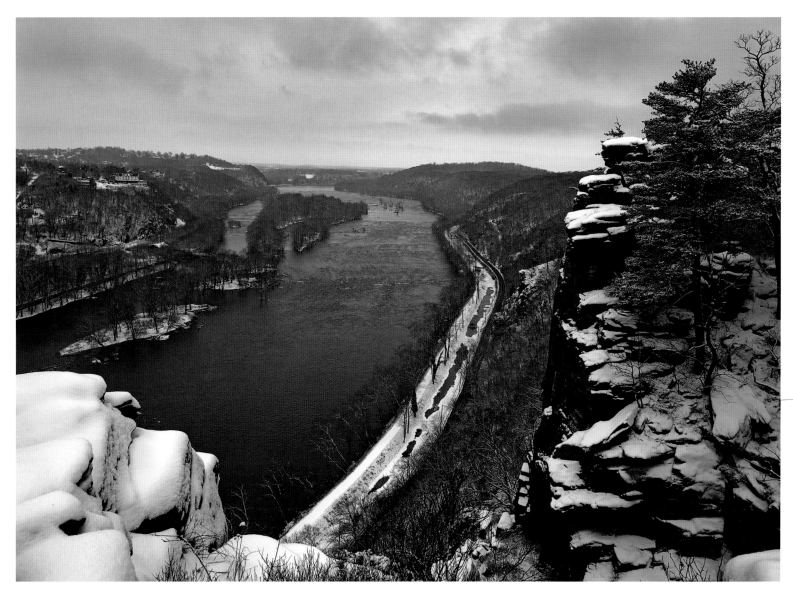

Winter brings solitude to the Harpers Ferry landscape. Since the end of the town's industrial age, mature trees have come to dominate the surrounding woodlands. A large majority of the park is now covered with deciduous forest. The lower floodplain along the Shenandoah River (opposite) abounds with silver maple, sycamore, and cottonwood. In part, the dramatic elevation change in the surrounding landscape accounts for the wide diversity of trees that cover the park from riverbank to ridge top (above). The rocky soils on the higher ridges are dominated by a variety of oaks—chestnut, black and northern red—as well as pine. Understory trees include red maple, black gum, and flowering dogwood. The base-rich soils on the lower, north-facing slopes support white ash, hackberry, and tulip poplar.

119

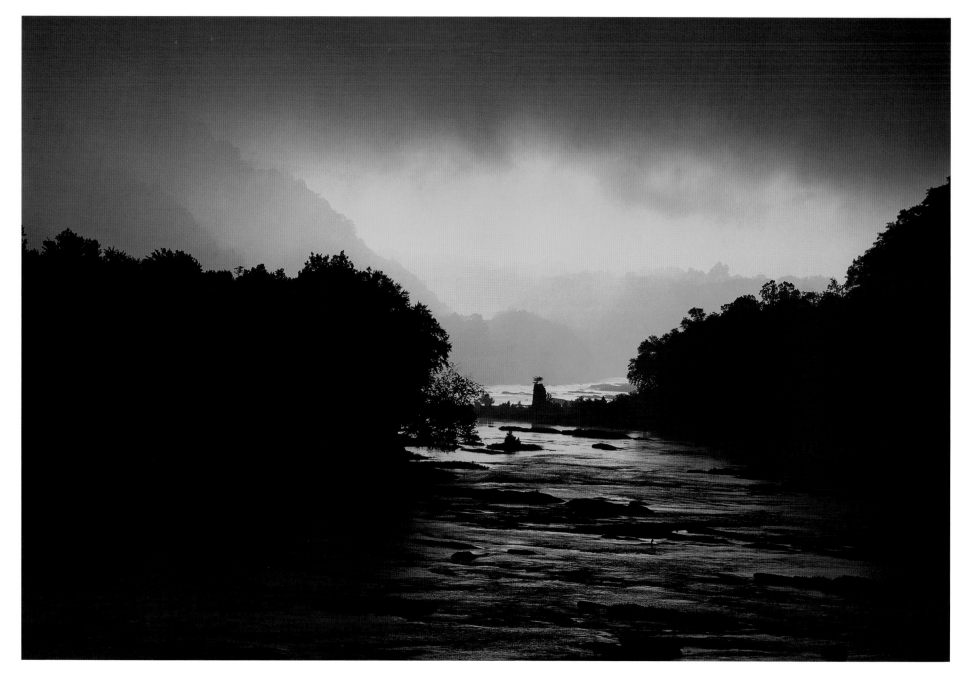

When Robert Harper arrived here in 1747, the place was known as "The Hole," no doubt named by some unimaginative pioneer who had passed this way. Living here at the time in a small cabin was Peter Stevens, who ran a ferry service of sorts. He paddled paying customers across the river in his canoe. Harper liked the place so much he bought it for 50 British guineas. When Harper discovered later that Stevens was a squatter, he had to purchase the property again from Lord Fairfax. The rest is history.